PARANORMAL
LONDON

GILLY PICKUP

AMBERLEY

First published 2018

Amberley Publishing
The Hill, Stroud
Gloucestershire, GL5 4EP

www.amberley-books.com

British Library Cataloguing in Publication Data.
A catalogue record for this book is available from the British Library.

ISBN 978 1 4456 8553 3 (print)
ISBN 978 1 4456 8554 0 (ebook)

Origination by Amberley Publishing.
Printed in Great Britain.

Contents

Introduction

If you are not a believer in the paranormal when you start to read this book, I can almost guarantee that you will be by the time you reach the end.

London's shadowed alleyways, ancient buildings and misty open spaces swarm with phantoms – spirits of the famous and the forgotten, the lovelorn and loveless, the damned, and the damnable. This book takes the bold ghost seeker on a hair-raising trip to explore some of the capital's spookiest places – that is, of course, if you are brave enough to accompany me on the chilling journey.

In this, the most haunted city on earth, I take you to visit haunts of murderers, sail on a phantom boat and if you're, erm, lucky, have close encounters with chilling manifestations at infamous No. 50 Berkeley Square and hear wails and tormented screams from Jack the Ripper's eternally restless victims as they roam the East End's cobbled streets.

Are you ready to see a headless duke, visit graves of plague victims and come into contact with an unseen force that tries to push you downstairs? And, to all those tremulous, heart-scampering souls among you, do not baulk at restless figures shrouded in shadow or menacing, stealthy footsteps; after all, it may only be your imagination playing tricks on you (unlikely though that is).

A recent survey suggests that some 60 per cent of us believe in ghosts, while 42 per cent claim to have experienced a supernatural encounter. That's a lot of people. But, you know, these days, to believe in – or at least not to pooh-pooh the paranormal – is not regarded as crazy; it is actually quite fashionable. Simply put, in this ever-changing world in which we live, ghosts are here to stay. In fact, I'd go further and say that ghosts are big business.

Packing this book's pages, these London spirits, phantoms, or whatever you want to call them come in all guises. There are malevolent aristocrats, monks, actors, white and grey ladies, a smattering of monarchs and wronged parlour maids. Of course, there is no shortage of modern-day ghosts as well as a naughty poltergeist, galloping horse, spectral dog and orbs galore (for those who don't know what an 'orb' is, it's a weird ball of light either seen by your own eyes – as have I – or captured in photos). Where can you go – or avoid going – to see the Black Nun? Do you want to spot the antique wheelchair that moves of its own accord, terrifying those who hear the approach of its squeaking wheels? What could you see from

Westminster Bridge on nights when the silver moon pokes ghostly fingers through the blackness? Where have two people been frightened to death – literally? Indeed, it's all truly spooky.

Many of the city's famous landmarks are haunted. The Tower of London, Westminster Abbey, St Paul's Cathedral, a clutch of West End theatres, the *Cutty Sark*, Queen's House in Greenwich and even Heathrow Airport and the O2 Arena. Besides that, hundreds of lesser-known sites claim paranormal happenings: pubs, hotels, parks and tunnels, churches, roads, Underground stations, banks, cinemas, council estates and the lake in St James's Park. To be honest, spooky nooks and crannies are everywhere in this fascinating, fat history book of a city, which has endured rioting, aerial bombardment, plague, devastating fire, civil war and terror attacks. London has survived everything history could throw at it.

It could be said London's phantoms seem strangely un-exorcisable, but then you know what they say: mortals live until they die, but ghosts hang around long afterwards…

Things You (maybe) Didn't Know About Ghosts

From ghoulies and ghosties and long-leggety beasties / And things that go bump in the night, Good Lord, deliver us!

Anonymous

- There are three types of ghost: interactive spirits (which are aware of you), residual hauntings (similar to a ghostly action replay), and demons (rare, but harmful).
- Ghosts may exist in a state of confusion and not have a clue what happened to them, why they are here, or why you cannot see or hear them.
- Spirits don't just appear in the hours of darkness; they are just as likely to appear in daylight.
- More ghosts are sighted in pubs than anywhere else.

Tips for Ghost Hunting

- A thermometer is a must for taking on a ghost hunt. It will detect fluctuations in temperature.
- Sprinkling some flour on the floor will reveal footprints. If you don't want to have a messy floor, put some newspaper down first and put some flour on that.
- Always thank the spirits after an investigation. A little gratitude goes a long way.

- It is easy for your mind to play tricks on you, especially somewhere that has haunted potential. Try to be objective and look for other possible reasons for strange events that occur.

Something strange in the neighbourhood … who you gonna call? (© Gilly Pickup)

CHAPTER ONE

Homes – Great and Small

It isn't only old buildings that can feel the chill of ghostly presences. There are weird goings-on in newer properties too. Some claims are, of course, fanciful. Others are mere sensationalism. Many, though, are just too strange to be ignored.

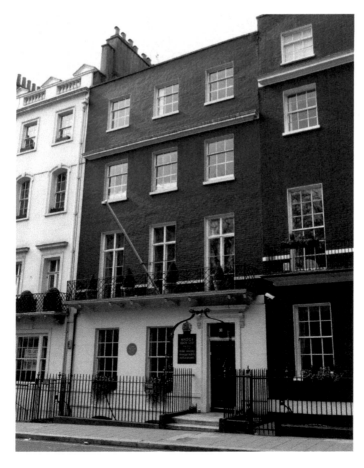

No. 50 Berkeley Square, is this London's most haunted house? (© Mike Pickup)

No. 50 Berkeley Square, W1

Oozing wealth and elegance, Berkeley Square has long been a home of the rich and famous. As a boy, Winston Churchill lived at No. 48; Horace Walpole, son of Prime Minister Robert Walpole, lived at No. 11; and Robert Clive of India bought No. 45 in 1761 and committed suicide there in 1774. Fictional Bertie Wooster and his valet Jeeves, creations of author P. G. Wodehouse, also lived in the square, which was even posh enough for Charles Rolls to be born there – that's Rolls as in Rolls-Royce, by the way. But it's No. 50 we're interested in here because it rejoices in the title 'London's most haunted house'. It is home to sellers of antique and first-edition books, Maggs Bros – isn't that a gloriously old-fashioned name for a shop?

Before Maggs Bros took over at No. 50, it was the home of former Prime Minister George Canning until he died in 1827. After that a Miss Curzon lived there until she died in 1859. So far, so quaint. But, of course, there is a more sinister side to this story.

'It seems that a Something or Other, very terrible indeed, haunts or did haunt a particular room. This … has been sufficiently awful to have caused the death, in convulsions, of at least two foolhardy persons who have dared to sleep in that chamber,' so said Charles Harper in his book *Haunted Houses*, published in 1907.

Some reports say that George Canning heard strange noises and experienced psychic phenomena while living there, but it was after Miss Curzon's death that the house gained a full-blown reputation for being seriously spooky.

Many stories relate to paranormal activity being at its busiest in the top-floor rooms. Theories have been bandied about as to why this is, but all we can do is piece together anecdotal fragments. After all, few who encountered the horrors of the house lived to tell the tale, and those who did survive were left insane.

A Mr Myers rented the building in the late 1800s. His fiancée called off their engagement and, broken-hearted, he became a recluse, hardly venturing from a room at the top of the house. After he died two people were said to have died of fright after staying in the same room, while another said Mr Myer's ghost chased him from the house.

Another story concerns a Mr Dupre, who lived here and kept his insane brother locked in a top-floor room. His groans could be heard in neighbouring houses and it is thought that, after he died, he was the spectre with a gaping jaw who terrified the wits out of anyone who saw him at a window. Other reports tell of an attic room haunted by a young woman called Adeline, who threw herself from a window to escape an abusive uncle. Yet another rumour is that a little girl was murdered in the top-floor nursery. She has been seen dressed in a tartan plaid, wringing her hands in despair and sobbing.

But, as we all know, stories like this become enhanced and embroidered over time and some incidents may well be the stuff of over-fertile imaginations. We must remember also that in the early nineteenth century, few poor and working-class Londoners could read or write. News that travelled by word of mouth was often misstated and exaggerated. As stories passed from person to person, reports about ghostly goings-on would have become distorted and mixed up.

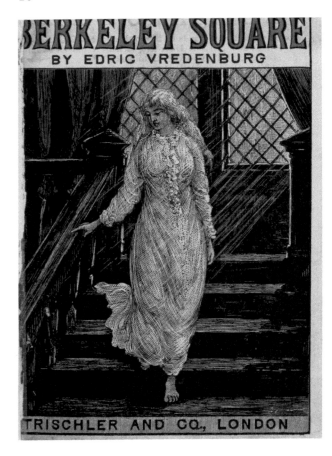

BERKELEY SQUARE

BY EDRIC VREDENBURG

TRISCHLER AND CO., LONDON

The haunted house on Berkeley Square – tales of unspeakable horror lie within. (Courtesy of the British Library)

However, there is a well-documented story about a maid who worked here in the 1800s. On her first night in the attic room, she woke the household with a piercing scream. Rushing in, they found her in a state of shock and when asked what was wrong, she could only describe what she saw as 'so horrible' before lapsing into unconsciousness. The following day she died in St George's Hospital, without having regained consciousness.

Another tale of death associated with one of the top-floor rooms is that of Sir Robert Warboys. His friend Lord Cholmondley had introduced him to John Benson, who at that time in the mid-1800s owned No. 50 Berkeley Square. One evening, over brandy and cigars, the subject turned to the hauntings in the house. Sir Robert threw his head back and laughed. 'Nonsense! No such thing as ghosts.' The other two set a wager of 100 guineas, saying that he would not spend a night in the haunted room. Sir Robert accepted. However, there must have been a degree of bravado and he couldn't have been totally sure as he took a bell to bed with him to raise the alarm if he saw or heard anything unusual. He carried a pistol for further protection. Shortly after, his companions heard the bell's frantic ring followed by shots. They ran to the room to find Sir Robert dead, his face set in an expression of sheer terror. The odd thing, though, was that there was no sign of a gunshot wound or bullets...

In his book *Phantoms of the Night* (1956) Elliot O'Donnell tells the story of two sailors who arrived from the West Indies on Christmas Eve 1887. Desperate for somewhere to stay but having squandered all their money, they came upon the empty building at No. 50 Berkeley Square. They broke in but found the downstairs rooms too damp to sleep in so went upstairs. Not long afterwards they heard footsteps ascending the staircase. Then something, described as 'a hideous, shapeless mass', burst into the room. Petrified and ignoring the screams of his companion, Martin threw himself downstairs and outside. In the meantime, Blunden, trapped in the room with the 'thing', jumped from a window. His body impaled itself on a spiked railing bordering the pavement, his face twisted in agony, eyes bulging from their sockets.

It was as if all Hell had let loose inside this house; had the powers of darkness taken over? Jessie Adelaide Middleton's *Grey Ghost Book* (Nash & Grayson, 1930) said of No. 50 Berkeley Square: 'the house contains at least one room of which the atmosphere is supernaturally fatal to body and mind. A girl saw, heard and felt such horror that she went mad ... A gentleman, a disbeliever in ghosts, dared to sleep in number 50 and was found a corpse after frantically ringing for help in vain.' Certainly sounds blood-curdling.

Other bizarre happenings include sounds of furniture being dragged across the floor, bells ringing, lights flashing and pain-racked screams from behind locked doors.

Street sign, Berkeley Square. (© Gilly Pickup)

While paranormal activity seems to have slowed in recent years, a police notice from the 1950s still hangs on the wall warning people not to ascend to the top floor.

In 2001 a woman working in the book shop said she witnessed a mass of brown mist. It moved across the room before vanishing. A few years later a cleaner felt someone's presence behind her, but on turning round no one was there, while a man walking upstairs had his glasses snatched and flung to the floor.

Was this a case of overactive imaginations or ghoulish presences that continue to haunt No. 50 Berkeley Square? If you pour scorn on the tales and refuse to believe that there may be something terrifying in the house, then ask yourself truthfully, would *you* stay the night alone in one of the top-floor rooms?

Avenue House, Finchley, N3

In the mid-1800s, Avenue House in East End Road, Finchley, was renovated by Henry Stephen, then in 1928 was opened to the public. There are reports of many spirits here, the most famous being that of a lady, a former governess, who appears when decorating works take place. Other paranormal occurrences include mysterious footsteps, feelings of being watched, cold spots and even light anomalies visible to the naked eye.

Kerry Truman, who with Steven Thomson runs the company Fright Nights London, told me, 'On our first visit to Avenue House we did our first walkaround before the event started. On the first floor we walked up six or so steps into another a room called

The seriously spooky Avenue House, East End Road. (Courtesy of Grim23 under Creative Commons 3.0)

Stephen's room. Just before walking into this room my stomach turned as if I was on a rollercoaster and I felt an impending feeling of doom which was odd. Two people with me felt exactly the same.' She continued, 'When we took the group up there no one said anything until our medium asked for a volunteer to stand outside Stephen's room. A lady came forward and within ten seconds was screaming and crying saying someone was after her and was going to rape and kill her. We didn't realise she was a sensitive and picking up on a spirit there.' Really scary stuff. Kerry said, 'The last time we went we were in the basement with torches when one lady was scratched on her arm and someone next to her had what appeared to be a burn on her face.'

Queen's House, Romney Road, Greenwich, SE10

The Queen's House, former royal residence in Greenwich, was built for James I of England and Anne of Denmark. In 1966 retired Canadians the Revd and Mrs Hardy, who had heard stories about the Tulip staircase, visited and took photographs. Back home, they developed them and saw they had captured the image of a shrouded figure appearing to ascend the stairs following a second and possibly third figure. As news of the photograph spread, members of the Ghost Club arranged to spend the night of 24 June 1967 in the house. Their purpose was to see the ghost or ghosts, 'film them, record them, or make contact with them by holding a séance in the vicinity of the staircase'. Instructions were issued to participants. They had to wear soft-soled shoes, synchronised watches and carry a torch, notebook and pencil. Everything was to be noted, from odd noises and smells to any feeling of a presence. Sadly, however, the vigil and séance produced no conclusive evidence. In 2002, though, a gallery assistant and some visitors reported seeing a figure disappear through a wall.

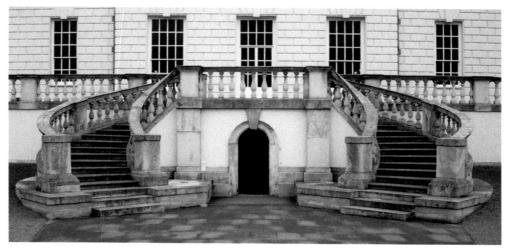

Former royal residence: the Queen's House, Greenwich. (Courtesy of cgpgrey.com under Creative Commons 3.0)

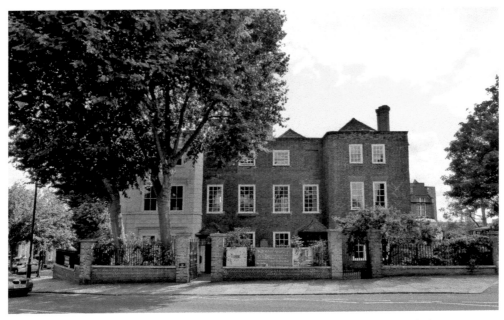

Exterior of Sutton House in Hackney, the site of spectral hounds and a 'white lady'. (Courtesy of Ethan Doyle White under Creative Commons 4.0)

Sutton House, Hackney, E9

Hackney's Grade I-listed Sutton House belonged to wool merchant John Machell in the sixteenth century. Besides spectral hounds, there is a phantom 'white lady' thought to be a woman called Frances who died giving birth to twins in 1574. Her apparition hovers around the building. During renovations in the 1990s, a student said he saw a lady who appeared before him before disappearing. Her appearance was accompanied by an overpowering smell of lavender perfume. The house been home to merchants, Huguenot silk weavers and Edwardian clergymen, and after falling into disrepair in the 1980s was occupied by squatters.

Charlton House, SE7

Built over 400 years ago for Sir Adam Newton, tutor to Prince Henry (son of James I), Charlton House played a vital role during the First World War when Sir Spencer and Lady Maryon-Wilson allowed the Red Cross use of their home. Rooms once occupied by the family became hospital wards. Since then several sightings have been reported, including the presence of a man on the original wooden staircase. A boy's bones were found when a lift was being installed, and during restoration work the mummified body of a baby was discovered in an old fireplace. Who they are, no one knows. Many staff refuse to enter the attic room alone due to feelings of oppression.

Keep your wits about you in this creepy alley near Charlton House. (© Lester Moyse)

Ham House, Richmond-upon-Thames, TW10

Ham House in Richmond-upon-Thames is one of England's most haunted houses. Employees have reported happenings that cannot easily be explained. Tales abound of mysterious footprints, doors opening and closing on empty rooms and phantom sightings. There is a ghostly antique wheelchair too. It has been known to move of its own accord, scaring the living daylights out of those who hear its squeaking wheels approach.

One lingering phantom is Elizabeth, Duchess of Lauderdale, who was reputed to dabble in witchcraft when she was alive. Footprints occasionally appear in her bedchamber. The earliest written account of a haunting is from Augustus Hare who visited and in his book *The Story of my Life* (1900) wrote of the Ham House ghost:

The old butler had a little girl ... then six years old ... The child, waking up, saw an old woman scratching with her finger against the wall close to the fireplace. The girl sat up to look at her. The noise she made in doing this caused the old woman to look round and she came to the foot of the bed. She stared at the child long and fixedly. So horrible was her stare that the child screamed. People ran in and the child told what she had seen. The wall was examined ... and concealed in it were papers which proved that in that room, Elizabeth had murdered her first husband to marry the Duke of Lauderdale.

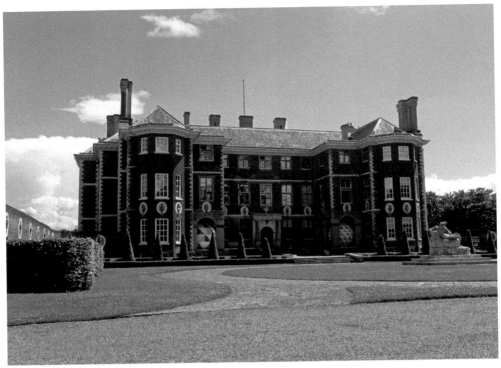

Ham House – will you see the spectral dog or the ghostly wheelchair? (Courtesy of Maxwell Hamilton under Creative Commons 2.0)

Another ghostly character was a son of the house. Heartbroken when jilted by a maidservant, he threw himself to his death from an upstairs window. If you listen carefully, you may hear ghostly weeping on the terrace where his body was found.

There have also been complaints from visitors about a King Charles spaniel who runs downstairs. Well, there is a 'no dogs' policy. The chilling truth is that this is a spectral dog who lived in the house centuries ago.

Grasmere House, Great Portland Street, W1

Up to now, we've looked at ghosts who strut their stuff in grand houses. But the following strange happenings took place in ordinary homes.

Grasmere House in Regent's Park estate has – or had – an eerie reputation. People living in some flats there became increasingly jumpy about a clanging noise that seemed to have no earthly explanation. They decided enough was enough and in 2016 residents called in a team of paranormal investigators to try and get to the bottom of it. However, they didn't solve the mystery. Phyllis L. who lives there said, 'It's gone now, but there was definitely something weird going on. I also saw the figure of a lady dressed in Victorian clothes who always appeared just after the clanging stopped.'

A haunted room in a
flat in Grasmere House.
(© Gilly Pickup)

Cooper Avenue, Walthamstow, E17

A council property in Cooper Avenue, Walthamstow, had a spooky 'white lady' who manifested in front of a small boy. The boy screamed and when his mother ran to see what was wrong he told her that the lady told him to 'get out' of the house. The family dog refused to enter the boy's bedroom.

Fairlop Road, Leytonstone, E11

And finally, a private house in Fairlop Road, Leytonstone, had a poltergeist. Polts are usually associated with adolescents, their appearance coinciding with a traumatic time for a teenager in the house. This particular poltergeist was blamed for pushing a pregnant woman downstairs. Fortunately, her unborn child was unhurt. The presence was also blamed for opening curtains and doors. No further activity has been reported here since the late 1990s.

Can you see something
spooky in here?
(© Gilly Pickup)

Hospitals

Lots of old hospitals have at least one ghost story attached. In his lifetime, veteran ghost hunter Andrew Green collected dozens of stories of hospital hauntings. Stories vary, but a common theme is a 'grey lady' or 'woman in white' who made a serious medical error and then committed suicide, only to reappear at times of crisis. Green believed that these apparitions are forms of electromagnetic energy, a faded echo of people whose lives were stressful. Many tales are passed down by word of mouth through generations of hospital staff.

University College Hospital, No. 235 Euston Road, NW1

University College Hospital has an extra member of staff who requires no salary. A ghostly Edwardian nurse still walks the wards. She's thought to be Lizzie Church, who accidentally killed her boyfriend with a morphine overdose and committed suicide in remorse.

This was the first hospital to have an operation carried out with the use of general anaesthetic. On 21 December 1846, Scot Dr Robert Liston, known as the 'fastest knife in Britain', amputated butler Frederick Churchill's leg in twenty-eight seconds. Liston was used to operating quickly, at a time when speed made a difference in terms of pain and survival. He held the scalpel in his teeth while sewing. However, although speed was doubtless of the essence, a story, perhaps fictional, tells that in his hurry to perform a thigh amputation, Liston once 'included two fingers of his assistant and both testes of his patient'.

Back to nurse Lizzie Church, who attended her lover's bedside in the 1890s. Her presence still occasionally appears to hospital staff as a reminder to be careful when morphine is administered.

Another apparition is philosopher and social reformer Jeremy Bentham, hailed as 'the first patron saint of animal rights', who died in 1832. He has been seen following staff around the hospital. In his will he specified that when he died he was to be dissected in the presence of friends and that his remains should be preserved and kept in the college grounds. Gruesome? Probably. But that was precisely what happened, and the skeleton and head were preserved and stored in a wooden cabinet. The skeleton, which had a

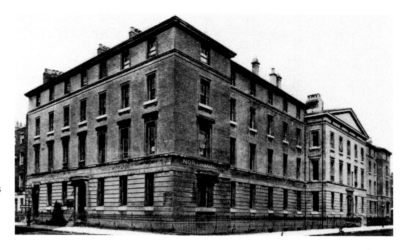

University College Hospital has a ghostly nurse or two. (Courtesy of Wellcome Images under Creative Commons 4.0; slide No. 4097, photo No. M0009669)

wax head fitted with some of Bentham's own hair, was padded with hay and dressed in Bentham's clothes. It was acquired by University College London in 1850.

A portrait of Marcus Beck, a surgeon here in the mid-1800s, hung on a wall until it was stolen in 2001. It was considered to be a cursed picture because anyone who fell asleep under it quickly took a turn for the worse and sometimes died.

St Bartholomew's Hospital, West Smithfield, EC1

Founded in 1123 as part of a monastery, St Bartholomew's Hospital has its fair share of ghost stories. A spectral nurse offers tea to patients in Bedford Fenwick Ward and another, referred to as the grey lady, prevents nurses from administering fatal overdoses in Grace Ward. However, the most active phantom is a murdered nurse who haunts the lift within a stairwell. Sometimes when a staff member has stepped into the lift at night or in the

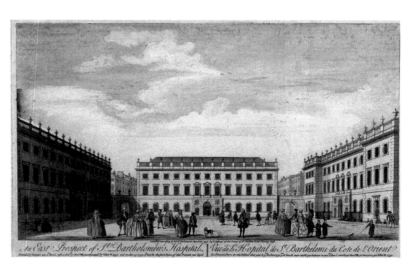

The courtyard of St Bartholomew's Hospital. (Courtesy of Wellcome Images under Creative Commons 4.0; Library ref. ICV No. 13265, photo No. V0012986)

early hours and pressed the button to be taken to an upper floor, the lights go off. The unfortunate person in the lift finds themselves moving slowly down to a basement. The lift doesn't budge until they get out and start walking up the shadowy stairwell towards their destination, only to realise that they are being followed slowly by the lift.

Queen Elizabeth Hospital for Children, Bethnal Green, E2

Bethnal Green's Queen Elizabeth Hospital for Children was formed of a merger between two hospitals. The building is now flats but has a chequered history that is doubtless responsible for the spectres seen and heard.

During the Second World War it was an emergency military hospital and later a prisoner of war camp. Later the building became the Hospital for Children in London and was opened in 1948 by HRH Princess Elizabeth, later Elizabeth II. In 1973 it became a hospital for people with learning disabilities and was closed in 1998. It gradually became derelict until the site was sold. One resident, let's call her Mary, told me, 'I was going to bed one night, not late, around 9.30 pm. I'd had a busy day and went to close the bedroom curtains. I nearly died of shock because there, clear as day before me, was an arm. It wasn't attached to a body, it was just hanging there in mid air. I screamed the place down and my neighbour across the passageway, she keeps my spare key, ran in wondering what on earth was wrong. I was so shocked, I was babbling, "there's an arm – look! – an arm." My neighbour looked at me in horror. "What are you speaking about Mary," she asked gently. "There's nothing there…"'

Royal London Hospital, Whitechapel, E1

Another spectral grey lady has been reported walking around the Royal London Hospital. Nurse Judith Y. was on duty one night when a lady in a grey nightdress came up to her asking if she could have a glass of water. The nurse said 'of course' and told the lady to return to bed, she would bring her water. Just then, another nurse came running across the ward. Judith reported, 'the young girl looked terrified. I immediately asked what the matter was and she said to me, "that lady, the one in grey, I've just seen her but she died last week"'.

CHAPTER THREE

Hostelries – Inns and Pubs

Plenty of spirits here, and not just those in bottles. Share a drink with a publican or bartender and, given a little encouragement, it is possible they will let you into some dark secrets embedded within the walls of their drinking hole. Many hostelries I've included in this book bristle with ghostly goings-on, a creepy crowd of pub spirits.

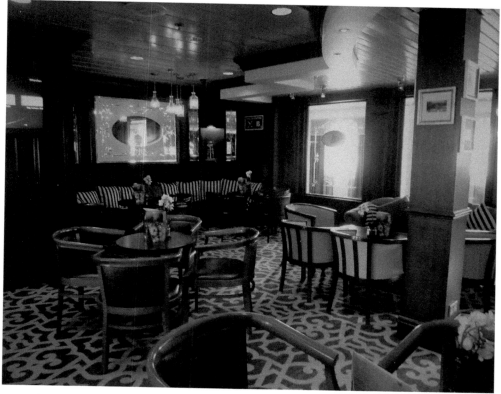

Lots of spirits – not the bottled kind – can cause havoc in pubs. (© Gilly Pickup)

Ship Tavern, Gate Street, WC2

Established in 1549, the Ship Tavern in Gate Street, Holborn, has had plenty of time to acquire a good stock of ghosts. In days gone by it was a favoured watering hole for posher folks of the day, such as shoemaker and antiquarian John Bagford and the

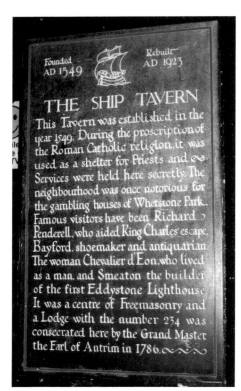

Above: The Ship Tavern, Gate Street, a site of paranormal activity. (Courtesy of Enchufla Con Clave under Creative Commons 4.0)

Left: Plaque outside the Ship Tavern. (Courtesy of Neddyseagoon under Creative Commons 3.0)

Chevalier d'Eon, French diplomat and spy, who lived the first fifty years of her life as a man and the final thirty-two as a woman. Richard Penderel – he helped Charles II to escape after the Battle of Worcester – liked to drink here too. Besides that, it was a secret meeting place for Catholics and there are those who declare the ghosts of those executed nearby still return to meet here.

During the reign of Henry VIII when Catholics were not allowed to practise their faith, some risked their lives to attend Mass in the tavern, which outlawed priests would conduct from behind the bar. A lookout would warn of imminent danger, giving priests time to escape into one of the pub's hidey holes. The congregation would pick up tankards and pretend there was nothing amiss. It was a risky business, though, because if they were discovered their fate was immediate execution.

In 1780 this was the sad end for priest James Archer and his congregation, and his presence is thought to be one that haunts the pub. Staff have reported hearing something being dragged across the basement while occasionally chilling screams rent the air. Sometimes a shadowy figure creeps slowly down the cellar stairs. What chilling tales these walls could tell if they could speak!

Strangely, given the grim background of the Catholic hauntings, the pub also has a happy, mischievous prankster entity who makes its presence known by hiding cooking utensils or moving the cellar keys to other parts of the pub – now you see it, now you don't!

The Spaniard's Inn, Hampstead, NW3

If you go to the Spaniard's Inn you might hear galloping hooves and see a phantom female. She occasionally scares the daylights out of those who spot her in the beer garden, but perhaps it's what you'd expect of the sixteenth-century inn, which is located on the edge of Hampstead Heath. Originally this was the country home of the Spanish ambassador to James I of England and VI of Scotland. The Spaniard's Inn has long been used to fame, after all it was immortalised in Charles Dickens's *The Pickwick Papers*; poets Byron and Keats visited too – apparently it gave them inspiration. It was also frequented by roguish highwayman Dick Turpin, who dropped by on his famous steed, Black Bess. Over the years, visitors have reported an invisible hand clutching their clothes. If that happens to you, please let me know.

The Flask, Highgate, N6

As far as ghosts go, The Flask in Highgate doesn't claim to have only one, it has two. One is said to be a barmaid who hanged herself in the cellar; the other is a young man in a Cavalier uniform, who you might see in the main bar. But then what is a good historic pub without a ghost or two?

The Flask harks back to an era when Highgate was a village on London's outskirts and the oldest part, the stable block, dates back to 1663. Its name comes from the tradition of selling flasks used to collect water from nearby springs.

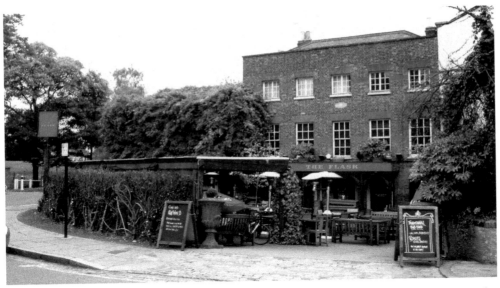

If you visit The Flask you might see the ghostly barmaid. (Courtesy of Ewan Munro under Creative Commons 2.0)

The pub's Committee Room was allegedly the scene of early autopsies, performed during the days of graverobbers who brought along bodies fresh from Highgate Cemetery.

William Hogarth was a regular patron and a story goes that he sketched a fight between two customers. No one knows where his drawing went, but a picture of the man himself is in the cellar room. Joan Wilson and Kate Bryanston sometimes visit the pub for a drink after work. They have felt or seen presences and have no doubt The Flask is haunted. 'One evening, the bar was busy and Kate and I were enjoying a drink with some friends,' Joan told me. 'The strangest thing happened. A glass on the bar suddenly rose up in the air and crashed onto the floor. I turned to Kate and said, "the ghost's at it again". "Rubbish," said one of our friends. "Obviously someone knocked it over." Just at that, as if to disprove the unbeliever, another glass on the bar did the same. The guy who had pooh-poohed us a minute earlier, turned white because he saw it that time too. We think it adds an extra dimension to a night out!'

Ten Bells Pub, Spitalfields, E1

Some of Jack the Ripper's victims frequented the Ten Bells Pub in London's East End. The pub was once called the 'Eight Bells Alehouse' but changed its name when the church nearby acquired more bells. Annie Chapman may have drunk there shortly before she was murdered, and poor Mary Kelly's remains were found close to the pub in November 1888.

Resident staff tell stories of an elderly man in Victorian garb who liked to crawl into bed with some of them before vanishing – naughty. A few years ago, a member of staff reported hearing someone chuckling outside his door, but of course when he

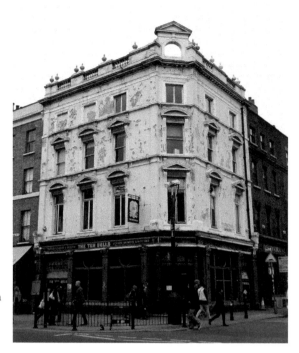

The Ten Bells pub in Spitalfields, which is frequented by some of Jack the Ripper's victims. (Courtesy of Ewan Munro under Creative Commons 2.0)

opened it there was no one there. On another occasion, he felt someone trying to push him downstairs. In recent years, a psychic refused to enter one room, sensing a terrible incident involving a baby, while a few months later someone discovered a bag containing Victorian baby clothes above the same room. And speaking of Annie Chapman, who was murdered near the pub at No. 29 Hanbury Street, now the site of a brewery, her shade has been seen in the area accompanied by a man – Jack the Ripper maybe?

The Grenadier, Belgravia, SW1

The Grenadier in Belgravia is haunted by a guards officer who appears every September. The pub, frequented by celebrities including Madonna and Gwyneth Paltrow, has its own sentry box outside.

The ghost, whose spectral exploits are described in framed newspaper cuttings on the walls, is as famous as the pub itself. The building used to be the mess for the Duke of Wellington's men and the story goes that the unfortunate officer was caught cheating at cards in an upstairs room. He was beaten up and subsequently fell, or may have been pushed, downstairs to his death. Throughout the years, landlords and bar staff have attested to unusual happenings. Sometimes the beer supply is cut off, weird spectral shapes appear, pets act strangely in the cellar and occasional wisps of smoke are seen when no one else is around.

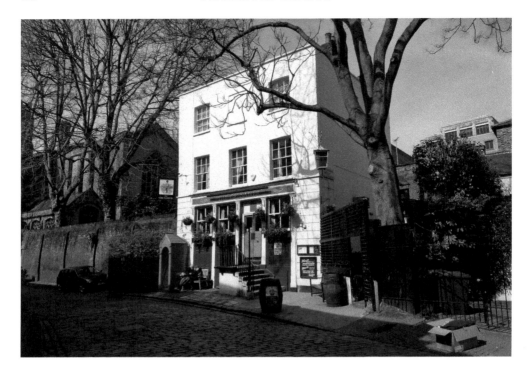

Above: Outside the haunted Grenadier pub in leafy Belgravia. (© Mike Pickup)

Left: The Grenadier pub, the site of many ghostly occurrences. (© Mike Pickup)

Will you encounter anything strange when you visit? (© Gilly Pickup)

John Snow Pub, Soho, W1

A shadowy figure with ghastly glowing red eyes and a face twisted into a grimace has been seen here. Was he a victim of the cholera epidemic? If you want to try to spot this tormented figure, head for the John Snow pub in Broadwick Street, Soho.

John Snow pub, Soho, where figures not of this world have been seen. (Courtesy of Ewan Munro under Creative Commons 2.0)

The pub was built on the site of Dr John Snow's surgery. He discovered that cholera was a waterborne disease after tracing an outbreak to a local water pump. It turned out to be contaminated with raw sewage from the homes of cholera sufferers. After the pump handle was removed, the epidemic ended.

Ye Olde Cheshire Cheese, Wine Office Court, EC4

Rebuilt shortly after the Great Fire of 1666, Fleet Street pub Ye Olde Cheshire Cheese lacks natural lighting, giving it a certain gloomy charm. The vaulted cellars are thought to belong to a thirteenth-century Carmelite monastery that once occupied the site. Back in the day, regulars included literary figures Sir Arthur Conan Doyle, G. K. Chesterton and Charles Dickens, who alludes to the pub in *A Tale of Two Cities*. An upstairs room was believed to have been used as a brothel in the mid-eighteenth century. There are ghostly tales aplenty here; noises have been heard in the cellars when no one is down there and occasionally visitors feel sudden icy-cold blasts, as if something otherworldly is passing by.

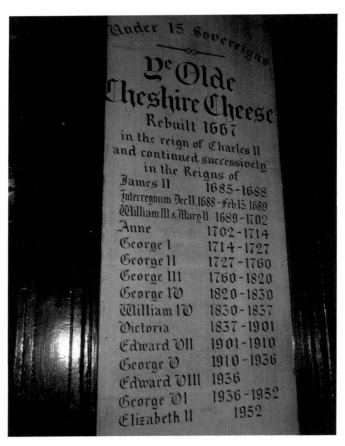

Ye Olde Cheshire Cheese, which was rebuilt in 1667. (© Mike Pickup)

Sign outside Ye Olde Cheshire Cheese, a pub mentioned in Charles Dickens's *Tale of Two Cities*. (© Mike Pickup)

The Dove, Upper Mall, W6

Rule Britania was written by James Thompson, but these days he is an otherworldly punter at The Dove. Several years ago the pub was ravaged by fire and up until then there were more ghosts. A staff member said, 'I see the spirit of a girl sometimes, she is naughty and turns on the beer taps or sometimes knocks things off the counter. I think

The Dove, Hammersmith, is haunted by an eighteenth-century girl. (Courtesy of Visit London Images/Britain on View)

perhaps she is the ghost of an 18th century girl whose job it was to clean the streets of horse manure.' To get back to James Thompson, he wears a top hat and cape and occasionally moves objects around. Those who have encountered him say he is not frightening.

The Viaduct Tavern, Newgate Street, EC1

This is the last remaining example of a Victorian gin palace in the city and has an unquiet ghost lurking in its cellars, besides one or two in the bar. The Viaduct is known for its paranormal activity. When electricians rolled up a carpet to work under the floorboards they reported seeing a 'thing' floating in the air and fall to the ground. When they approached, it simply disappeared. The Viaduct Tavern is believed to be on the site of the former Newgate Prison. Some staff members won't go into the basement alone, while several have reported seeing apparitions there.

Lantern Ghost Tours (lanternghosttours.com) owner Jacqui Travaglia told me:

I was running a ghost tour at the Viaduct Tavern in October 2017 with a group of guests. We were using an Ouija board in the old basement. There were six guests and a friend of mine. We all felt a cold chill around our legs as if it was moving among us. I saw what looked like a shadow of a tall man wearing a cape and hat in the doorway

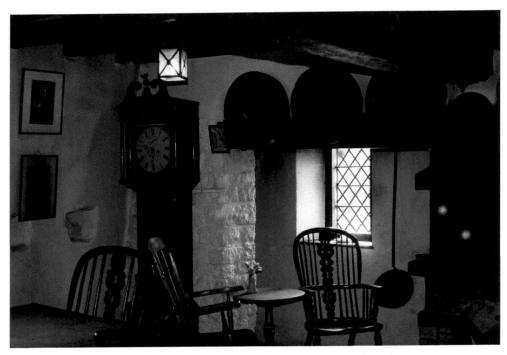

Ghostly orbs in the lounge bar or simply a trick of the light? (© Gilly Pickup)

staring at us. My right arm lost feeling and my friend Brett and two guests also saw him. We stopped the ouija board and left the basement as we felt unwelcome. The guests felt nauseous and we needed to debrief in the fresh air outside to ground ourselves before continuing.

This is just one of many experiences I've had over the years that created my passion for the spirit world. My passion soon consumed the majority of my time and I started Lantern Ghost Tours, sharing my love of haunted locations with guests from around the world. Our guests have the opportunity to visit haunted locations and discover hidden history. They can also hunt ghosts with our paranormal investigators.

Enjoy a drink with a spook or two. (© Gilly Pickup)

Hotels

Grange Group of Hotels (locations across London)

Most hotels deny the presence of anything spooky in case it scares potential guests away. How refreshing therefore to find Grange Hotels group, who not only admit to having a spectre but on their website tell of several phantoms.

The lounge of the Grange Blooms Hotel near the British Museum is haunted by the ghost of Dr John Cumming, a Scottish minister who liked to interpret Old and New Testament prophecies and was particularly interested in those regarding the end of the world. A ghostly apparition thought to be that of the man himself has been spotted sitting engrossed in a book.

Grange City Hotel incorporates the last remaining section of London's Roman wall and, as a result, its bloody history. After the Romans abandoned the city over 2,000 years ago, the city walls were rumoured to be haunted. If you listen carefully, you might hear Roman sentries patrolling the walls.

Part of the lounge area haunted by a man sitting with a book.
(© Gilly Pickup)

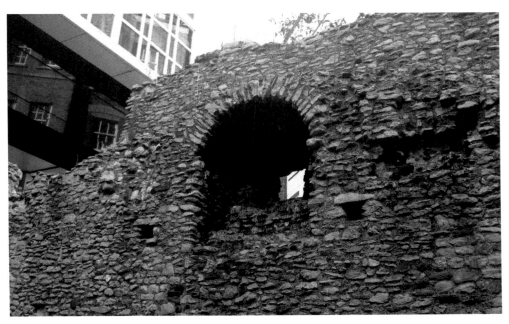

A fragment of the London Wall in the courtyard of Grange City Hotel. (Courtesy of Adam B. Morgan under Creative Commons 1.0)

Grange Wellington Hotel in Vincent Square was originally a hospital called the Pimlico and Westminster Institute. Opened in the 1860s, the staff worked in fear of a surgeon who kept strict discipline by means of his walking stick. They were terrified when they heard the knock-knock of the stick, heralding his approach. Today hotel staff and guests have reported hearing a creepy knocking – is the surgeon still making his rounds?

On bleak, stormy nights visitors to Grange St Paul's may hear the click-clack of the telephone exchange that was once there. Rumour says the ghost of an operator is still trying to connect the call that caused her electrocution.

Way down below the Grange Holborn is the abandoned British Museum Tube station. From the hotel cellar screams of the malevolent spirit that haunts the station can be heard. It is said that the long-abandoned tunnels are haunted by the ghost of Egyptian god Amun-Ra, an apparition blamed for the disappearance of two women from Holborn station in 1935. It would seem sensible, therefore, if you are staying in the Grange Holborn not to search for any underground passages.

Langham Hotel, Marylebone, W1

Europe's first 'Grand Hotel', the Langham is an ostentatious building with interiors lavish to the point of bombast. Over 2,000 people, including HRH the Prince of Wales who later became Edward VII, attended the glittering gala opening on 10 June 1865. Anyone staying at the Langham Hotel was automatically assumed to be of

high standing. Roll those credits for Mark Twain, Arnold Bennett, Arthur Conan Doyle, Noel Coward, Napoleon III, Mrs Wallis Simpson and Diana, Princess of Wales. The composer Dvorak visited too, although he managed to offend the management when, in an attempt to save money, he requested a double room for himself and his twenty-year-old daughter. The hotel was also the setting for several of Arthur Conan Doyle's Sherlock Holmes stories, including the chilling *Sign of Four*.

Not only was the Langham the first hotel with state-of-the-art fire protection and hydraulic lifts, or 'rising rooms' as they were known, but it had – indeed, still has – another rather more sinister claim to fame as one of England's most haunted hotels. This hotel has somehow acquired a sheer embarrassment of spooks during its history, reportedly having up to seven ghosts.

At one point, the Langham's popularity waned and it closed. When it reopened it had a change of purpose as administrative offices for the BBC. Several third-floor rooms became staff quarters for those whose working hours necessitated an overnight stay. Many sightings come from this time.

The spectre of a tall, silver-haired man dressed in cloak and cravat frequents the upper floors. Although his description sounds harmless, those who have encountered him say he is 'a terrifying figure' with 'blank staring eyes'. Whispers are that he is the spirit of a doctor rumoured to have killed himself after murdering his wife while they honeymooned in the hotel.

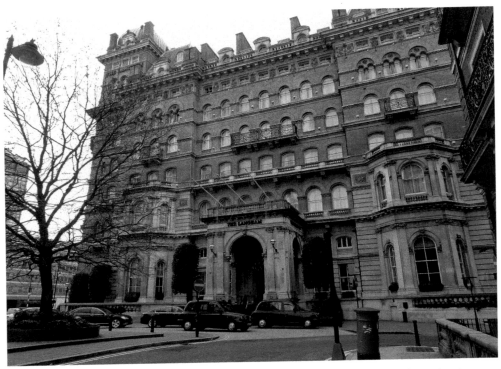

Exterior of the Langham Hotel – is this Europe's most haunted hotel? (© Mike Pickup)

In another room – formerly a BBC reference library – occupants report sharp drops in temperature that heralds the arrival of an eighteenth-century footman wearing a powdered wig. This figure is thought to be a good-natured apparition from the days before the Langham became a hotel and Foley Mansion stood here. It often happens that ghosts from times gone by return to reclaim places they knew well in life.

Several BBC personnel say they also experienced the antics of a mischievous spirit in Room 632, who would tip sleeping night-shift staff out of bed. Regular occurrences continued with the last chilling experience taking place in 2002 when a guest found himself lying on the floor after 'something unseen but with huge strength' pushed him out of bed.

There have also been sightings of a phantom butler wandering the corridors before dissolving into thin air, though he seems to have gone now as his apparition has not been witnessed since 1974.

All well and spooky, but by far the most nerve racking of all inexplicable happenings in the Langham is the phantom of Room 333. Mock if you will, but it scares the living daylights out of most of those who check into that room.

In 1973, James Alexander Gordon, reader of football results on BBC Radio, awoke in the night to see a fluorescent ball hovering in the room. It took on the shape of a man dressed in Victorian eveningwear. Summoning up his courage, the terrified presenter asked the apparition who it was and what it wanted. The question seemed to irritate the being and it began to float towards him. This was bad enough, but it was even more blood-curdling as its legs seemed to be cut off from just below the knee. The announcer removed a shoe to throw at the phantom and the presence vanished – at least for the rest of the night. Later, when he told his colleagues about his ordeal, others told of seeing the apparition in the same room. Why did the ghoul look as if his legs were cut off? Because the floors had been raised since Victorian times, when central heating pipes were installed.

There are more eerie goings-on here. A German prince who committed suicide by jumping from a fourth-floor window at the start of the First World War has been

Sign outside the
Langham Hotel.
(© Mike Pickup)

spotted. Although his antics are not solely confined to Room 333, he seems to have a particular penchant for that room. BBC announcer, the late Ray Moore, described him as 'beefy, cropped hair, sporting a military-style jacket buttoned up to the neck'. He has been observed several times walking through closed doors and is rated the hotel's most active apparition.

After the BBC moved out, the hotel had a makeover before being reopened by the Hilton hotel group in 1991. The building work didn't deter the phantoms though. Emperor Napoleon III, who lived at the Langham during his last days in exile, still haunts the basement, while a more blood-curdling sight is that of a man with gaping facial wound who haunts hallways late at night.

But let's go back to Room 333. Designer Lily Brown said a friend of hers saw the apparition. She screamed and, like James Alexander Gordon, hurled her shoe at it. The footwear passed right through the phantom but did not deter it as it kept moving towards her, its face contorted in a dreadful grimace.

In May 2003 a female guest checked out of the hotel one night without giving any reason for her premature departure. Later she contacted the management, explaining that her slumbers had been interrupted by the activities of 'the spectre', who kept her from sleep by repeatedly shaking the bed.

More recently, during the 2014 test match, members of the cricket team reported paranormal goings-on. Some of their wives refused to stay in the hotel. England bowler Stuart Broad recounted one experience to the *Daily Mail* during his stay that forced him to move rooms. He said the bathroom taps came on for no reason. When he turned on the light, the taps turned off. Switching the light off again, the taps started running. Broad was reported as saying Ben Stokes also had problems. Broad said, 'He's on the third floor, which is where a lot of the issues are. I'm telling you, something weird is going on.'

Why is this room apparently haunted by so many apparitions? Is it because the number 333 represents the Holy Trinity? Is it because when doubled it is the number of the Devil? Or is it because 3 a.m. is the demonic witching hour and, of all the minutes in that hour, 3:33 a.m. is considered by some to be the Devil's favourite time of day? Perhaps we will never know.

While researching and writing this, I requested more information from the current hotel management, but they chose to make no comment.

Georgian House Hotel, St George's Drive, SW1

Hauntings take place mainly on the top floors of the Georgian House Hotel, although ghostly goings-on have been reported elsewhere in the building. The most commonly spotted spirits are that of an old man and children. In 1991 a staff member stayed overnight in a room and woke to find an old man sitting at the foot of the bed. He then got up and left with no explanation. In the morning the staff member was angry at the hotel manager for giving out a spare key to the room. The manager informed her that there is no spare key and she had the only copy. On other occasions guests have complained of noisy children on the floors above running along corridors, giggling and

banging doors. After reporting the issue to reception staff, it is often the case that there are no children staying in the hotel. A former employee claims to have seen children. She said she assured them that they were welcome to play on the upper floors.

Before the building became a hotel it was an apartment block, so the ghosts could be former residents. However, there is no evidence that they are anything other than friendly or simply curious.

Cadogan Hotel, Knightsbridge, SW1

Actress Lillie Langtry lived at No. 21 Pont Street, a building annexed as part of Cadogan Hotel in Knightsbridge. She sold her home, where she was said to have seduced the future Edward VII, to the owner of the hotel on the understanding that she could keep her bedroom, Room 109, entertain guests and eat free in the hotel's restaurant. Lillie usually appears around Christmastime in the hotel restaurant when it is quiet.

While Lillie died in Monaco, it is not unusual for spirits to return to haunt their former homes, even if they moved some years before their death. Perhaps this is the case with Lillie. Maybe the Cadogan is where her spirit feels most comfortable.

 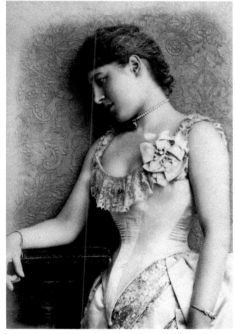

Above left: Exterior of the Cadogan Hotel, where Lillie Langtry once lived and where she returns every now and then. (Courtesy of Spudgun67 under Creative Commons 4.0)

Above right: Actress Lillie Langtry, photographed by William Downey in 1885. (Courtesy of The National Archives)

CHAPTER FIVE

Museums

Museums are windows into the past – where better for the odd phantom to hang out?

Victoria and Albert Museum, Knightsbridge, SW7

If you go to the Victoria and Albert Museum in Knightsbridge you might get up close and marvel at the Great Bed of Ware's immense girth and vast depths. The bed, dating back to around 1590, is massive even by today's standards – 10 feet 9 inches square and 7 feet 6 inches high. It is heavy too, weighing 641 kilograms (almost 101 stone). The Great Bed of Ware is the only known example of a bed this size.

The carved oak four-poster was built by Jonas Fosbrooke, a carpenter from Ware and was originally kept in a local inn. Rumour has it that he made it for a member of the royal family, but this cannot be verified.

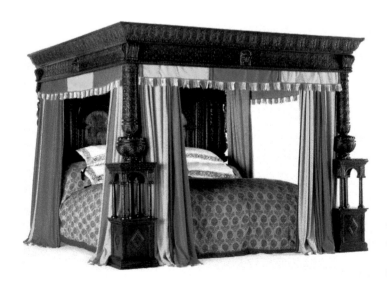

The massive, carved oak Great Bed of Ware 1590–1760. (© Victoria and Albert Museum)

Because of Ware's position on the Old North Road, it became an important coach stop between 1400 and 1700. It was a popular overnight destination for pilgrims travelling from London to Walsingham or those going to Cambridge University. In *The Canterbury Tales* Geoffrey Chaucer mentions the town twice, naming his notorious cook 'Roger Hogg of Ware'.

The bed was moved to various locations including the Saracen's Head pub and was acquired by the V&A in 1931.

The bed became famous and was referenced by Byron in *Don Juan* and Shakespeare in *Twelfth Night* when Sir Toby Belch describes a piece of paper as 'big enough for the Bed of Ware'. Reference was also made to it in George Farquhar's play *The Recruiting Officer* (1706) in which a bed is 'bigger by half than the Great Bed of Ware'. Visitors and those who slept in it sometimes carved their initials – still visible on the bedposts and headboard.

During its time in Ware it was reputed to have accommodated '12 London butchers and their wives', probably as a dare, each of whom had to take care not to sleep next to an unrelated member of the opposite sex, otherwise he or she would itch for seven years. Some stories say as many as twenty-six people have slept in it at any one time, though this is probably an exaggeration.

Not only was the bed famous for its size but also for the fact it was haunted. Those who tried to sleep in it were kept awake by 'pinching, nipping and scratching that went on all night long'. People became scared and refused to sleep in it. Who was the ghost involved? Many believe it was that of old Fosbrooke, furious that the hoi polloi was using his bed. (Phantom fits of pique, maybe?)

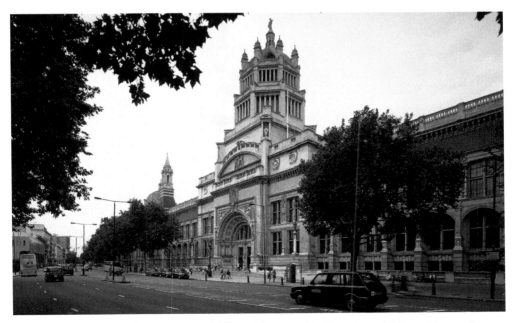

The main entrance of the Victoria and Albert Museum. (© Victoria and Albert Museum)

Handel and Hendrix Museum, Mayfair, W1

In 1723, George Frederic Handel moved into No. 25 Brook Street, Mayfair, where he lived for thirty-six years and died in the upstairs bedroom. Fast-forward to the year 2000, when part of the building was leased to the Handel House Trust, and the building, together with the house next door, is called the Handel and Hendrix Museum.

In November 2001 the trust made an announcement: 'Handel's spirit was brought back ... when the Handel House Museum opened to the public.' This may have been an unfortunate turn of phrase, however, because during the restoration project there were indeed reports of a spirit – of an ethereal kind – haunting the building. The hauntings were considered bad enough for the trust to ask a local priest if he could lay to rest the ghost that at least two people claimed to have encountered.

'We weren't sure whether having a ghost would attract or deter customers,' commented Martin Egglestone (trust fundraiser), who twice felt the apparition in the room where Handel died. In June 2001 he was in the room and said, 'suddenly the air got very thick.' He described seeing a shape like 'the imprint on the back of your retina when you close your eyes, having been looking at the sun for too long'. Mr Egglestone said he thought the spirit was a woman. He said, 'It felt like the pressure you get when you brush past someone in the Tube and they are too close to you.' The sighting was confirmed by another employee. Staff also reported a scent of perfume in that room.

Opening night Handel and Hendrix museum. (© Handel and Hendrix in London & Visitlondon.com)

Although Handel lived only with his manservant, two sopranos, Faustina Bordoni and Francesca Cuzzoni, frequently visited. 'There is a possibility that the ghost might be one of them,' said Mr Egglestone, 'but they would probably have sung in the room where he had his harpsichord on the floor below the bedroom.'

Interestingly, the upper storeys of No. 23 next door, part of the Handel House, now part of the museum and used for exhibitions, was the home of rock legend Jimi Hendrix from 1968 to 1969. He claimed to have seen a ghost on the premises while he lived there. A local priest, who wished to remain anonymous, said water was sprinkled and a prayer read out to try to send the apparition away. 'This is a soul who is restless and not at home,' he told the *Daily Telegraph*. 'I don't see it as evil or horrible and one should help it to be at peace.'

Ragged School Museum, Tower Hamlets, E3

These days the Ragged School Museum in Tower Hamlets is a popular visitor attraction. Its reconstructed Victorian classroom is equipped with desks, slates, chalks, blackboards, easels and a real blast from the past – dunce caps. Victorian costumed actors give lessons while a kitchen displays historical objects, all designed for hands-on inspection.

Originally this was a school for poor children, established in 1877 by Dr Barnardo. He wanted underprivileged East End children to have a basic education and 'ragged schools' provided tuition, food and clothes. It is not unusual to have a degree of spectral activity in such a place and visitors have heard children's cries and laughter,

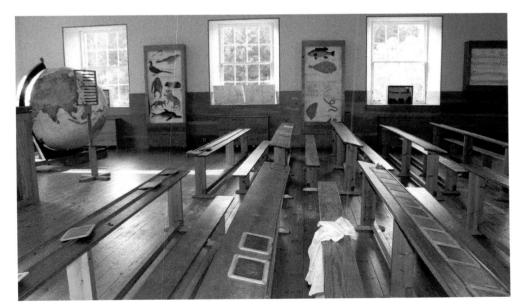

A classroom in the Ragged School. (© Gilly Pickup)

felt clothes being tugged while ghost hunters encounter floating orbs and disembodied voices, with some captured on tape. Anyway, to get back to Dr Barnardo, he must have been kind because records say that in 1881 he took 2,500 Sunday school children by train on an outing to Theydon Bois in Essex. That's a whole lot of kids to look out for.

Kerry Truman and Steven Thompson, who run Fright Nights London, told me that the Ragged School is one of the most active places they have been to. Kerry said,

> On our first event there last year, we heard a child giggling at 2.30 a.m. in one of the classrooms. On the top floor of the building, one of the group felt there was someone standing behind him. We asked him to stand in the next room on his own and he did so. After about 30 seconds I asked him if he was okay but didn't get a response. I went into the room to find him standing in the opposite corner facing the wall. I walked over to him and saw he was crying. He couldn't explain why he was crying or why he was standing in the corner but that he felt compelled to do so.

Kitchen in the Ragged School. (© Gilly Pickup)

Kitchenware from times past. (© Gilly Pickup)

When our investigation continued into smaller groups, I was in the basement with one group who reported seeing a man standing there. The whole group could see him – I couldn't see anything – and then suddenly they all screamed and told me he lunged at them before disappearing.

Bruce Castle Museum, Tottenham, N17

This sixteenth-century manor house, now the Bruce Castle Museum in Lordship Lane, Tottenham, is haunted by one of Lord Coleraine's wives. In the 1600s, the house and land was owned by Hugh Hare, 1st Lord Coleraine, who died a horrible death in 1667 by choking on a turkey bone: 'Being at supper ... and talking merrily with some gentlemen of his acquaintance and having a turkey bone in his mouth, it was hard hap through extreme laughter to cause it to go down the wrong way which was ye instrument of his death.' Beware of turkey bones, it seems.

This allowed Henry Hare, 2nd Lord Coleraine, to inherit the house and move in with his wife Constantia Lucy. As time went on, Henry grew tired of his wife and banished her to a room at the top of the house and locked her in. Constantia grew very unhappy and one day jumped off the balcony, killing herself and her unborn child. Now she haunts Bruce Castle and her wistful figure has been seen looking out of the window at nightfall. She has been spotted several times over the years. The first written reference to the ghost was in the *Tottenham & Edmonton Advertiser* of March 1858.

Bruce Castle Museum, haunted by Lord Coleraine's wife, Constantia. (© Gilly Pickup)

CHAPTER SIX

Open Spaces

Hampstead Heath, North-West London

Think you're safe outside, in a green space brimming with wild flowers, birdsong and trees? Read on, you might just change your mind. Take Hampstead Heath for instance, an ancient park first documented in 986 when Ethelred the Unready granted one of his servants 'five hides of land at Hemstede'. When it comes to paranormal activity, it's busy here.

Jim B. and his friend were out walking early one morning and saw a middle-aged female apparition walk towards them on Parliament Hill. The men reported hearing wind chimes and at the same time were almost choked by what they described as 'an overpowering, acrid smell, like incense or something'. They described the vision as

Who knows what otherworldly beings you may encounter in unexpected places.
(© Gilly Pickup)

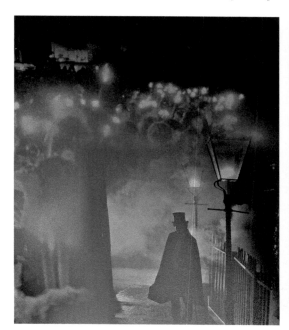

Above left: Spirits of the dark. (© YTB_A5, author's collection)

Above right: The Heath, where you may meet a phantom woman or a ghostly horseman. (© Gilly Pickup)

wearing a bonnet, long dress and red shawl. The pair said they saw her for around five seconds before she disappeared. Jim said, 'Before this, I wouldn't say I believed in ghosts exactly, but am open to the idea that there might be more to this life than we know.'

The Heath is also home to a ghostly horseman, whose galloping phantom has been known to race hell for leather towards astonished witnesses.

St James Park, SW1

Following the Restoration of the Monarchy, jovial Charles II made major changes to St James's Park. He ordered the redesign, which included laying lawns and planting avenues of trees. He decided that this once swampy wasteland should have a canal as a magnificent centerpiece. After it was finished, the park was opened to the public. Charles II entertained guests here and it was where he courted his favourite mistress, Nell Gwyn. Diarist John Evelyn wrote in 1671: 'I had a faire opportunity of talking to his Majestie ... & thence walked with him thro St. James's Parke to the Garden, where I both saw and heard a very familiar discourse between ... [the King] & Mrs. Nellie.'

However, the park also gained an unsavoury reputation. The poet Rochester describes the park: 'Carmen, divines, great lords and tailors, / Prentices, poets, pimps, and jailers, / Footmen, fine fops do here arrive, / And here promiscuously they swive.'

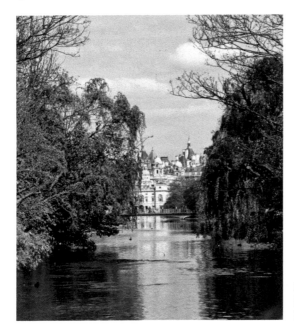

St James's Park, London's oldest Royal
Park. (© Pawel Libera/London &
Partners/Visitlondon.com)

Even a century later it wasn't one of the best places to go after dark. A reader, who
called himself 'A Pedestrian' wrote to the *Daily Telegraph* in 1855 to complain that
he was constantly annoyed by prostitutes on his route through St James's Park from
Westminster to Piccadilly. 'I have complained to the police until I am tired of doing so,
the only answer I ever get being, "Then you should go another way."'

But to have a gander at the origin of the ghoul in this anecdote, we go back to the
eighteenth century when Horse Guards Parade was created after part of the canal was
filled in. Soon after, the rest of the canal became a lake with a gruesome story attached.

A sergeant, or according to some versions, an officer, in the Coldstream Guards
murdered his wife and beheaded her. However, when he threw her body in the lake
another soldier saw him.

There is no record of what happened to the murderer but there have been sightings
of the woman's ghost in this, London's oldest royal park. Sometimes she walks from
Cockpit Steps towards the lake; at other times she rises eerily from the water. Some
say she wears a 'red stripe' dress, others say she wears a pale dress drenched in blood.
Sometimes blood gushes from her neck and when she appears there have been reports
of a sickly smell of fresh blood. Sometimes she beckons to visitors. The consensus is
that it is not a good idea to go towards her.

There used to be a barracks in the park and the sight of the Red Lady once terrified
two soldiers according to *The Times* in January 1804. They were so petrified that they
were unfit to return to duty for some time.

Is this stuff and nonsense? Maybe, but in 1972 a car driver who veered off the road
nearby was acquitted of dangerous driving when the apparition was cited as cause.
Interestingly, it seems the legal establishment accepted the existence of the spectre.

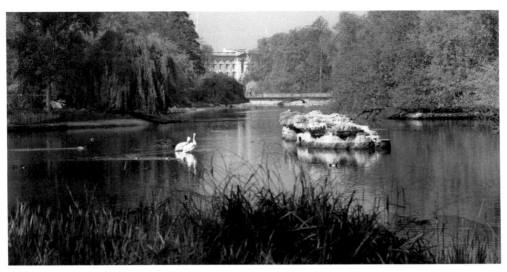

The lake in St James's Park where a blood-spattered woman rises from the water. (© Greywolf/ The Royal Parks)

Bleeding Heart Yard, Farringdon, EC1

In the seventeenth century Lady Elizabeth Hatton was brutally murdered in the stirringly named Bleeding Heart Yard because, the story goes, she dallied with the Devil.

In the 1600s a grand ball took place at Hatton House, where Lady Hatton played the leading role. She was young, beautiful and wealthy and had no trouble attracting

Bleeding Heart Yard, where Lady Elizabeth Hatton was 'torn limb from limb' in the seventeenth century. (Courtesy of Duncan Harris under Creative Commons 2.0)

men's attention. When the evening was in full swing, a man dressed head to toe in black walked in, took Lady Hatton's hand and they danced round the room. The man had a clawed right hand. The couple created a stir when they danced through the doors into the garden and vanished.

The next morning her body was found on the cobblestones 'torn limb for limb, but her heart still pumping blood'. It's no wonder that her ghost haunts this creepy cul-de-sac.

Smithfield, EC1

Another outdoorsy place to avoid – or head for, depending on your desire to see or steer clear of anything spooky – includes the area around the Martyrs' Memorial at Smithfield, where 277 Protestants were burnt alive for their beliefs. There have been reports of cries and screams late at night.

Green Park, SW1

Green Park has several wandering spirits, but one of the most fearsome lurks in the shadow of a plane tree. This otherworldly being has a pig-like face with a wolf's mouth. Stories abound, but it is most commonly said that several men have died under

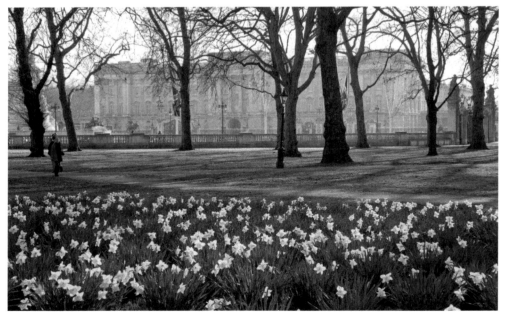

The Green Park and Buckingham Palace – who knows what might happen if you fall asleep beneath a tree here. (© Greywolf/The Royal Parks)

The Green Park at Constitution Hill.
A burial ground lies below the park.
(© Greywolf/The Royal Parks)

this tree, while women feel a 'cruel hatred' towards men when near it. It is best to avoid it if you happen to be female and out with your male friend.

Another story dates back to the 1930s, when a tramp called Black Sally met a horrible death in Green Park. The story goes that Sally ignored warnings not to sleep beneath this particular tree, where mysterious things had a nasty habit of happening. Whispers abounded that people who fell asleep here never woke up again. Birds shunned this tree, they never lingered on its branches and no wild flowers grew beneath it. Maybe there is another explanation for the lack of flowers and mysterious goings-on in Green Park, though, because the burial ground of a leper hospital is beneath the park.

Westminster Bridge, SW1

If you venture on to Westminster Bridge on 31 December, remember to look eastwards as midnight approaches. That is the best time to see a ghost of one of London's most infamous criminals, Jack the Ripper. The shadowy figure simply materialises on the parapet of the bridge before jumping into the River Thames. And yes, everyone knows the Ripper is chiefly associated with the East End, so why does his ghost

haunt Westminster Bridge? One of the dastardly Ripper suspects, Montague Druitt, committed suicide here in December 1888...

This is also where you may see a ghost ship, a phantom vessel crewed by three men. The boat sails towards Westminster Bridge before vanishing. The phantom ship was last reported in 2014 when a lifeboat crew was called out after receiving reports of a ship apparently in trouble.

Palace of Westminster and Westminster Bridge, where a shadowy figure appears on the parapet. (Courtesy of Justin Norris under Creative Commons 2.0)

Royal Palaces

The Tower of London, EC3

Beheadings, murders, torture and hangings: all manner of grisly things happened in the Tower of London, so it's hardly surprising that a phantom or two – let's be truthful, there are many more than two – linger within its stone walls. Over the past 900 years the building has developed the reputation of being one of Britain's most haunted places. This royal palace and secure fortress has served as an armoury, treasury, menagerie and home of the Royal Mint.

One famous story is that of the two young princes who disappeared in tragic circumstances from the Bloody Tower. No one knows exactly what happened to

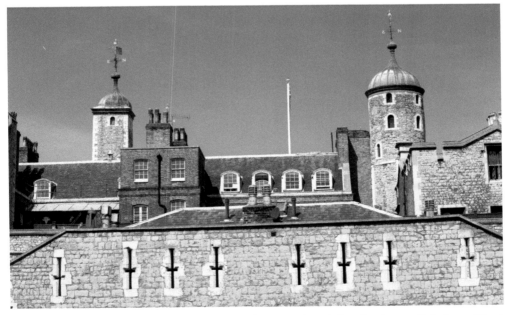

The Tower of London, royal palace and secure fortress. (© Visit London images/Britain on View)

Tower of London – Bloody Tower portcullis. (© Historic Royal Palaces & Nick Guttridge)

twelve-year-old Edward and ten-year-old Richard, Duke of York, sons of Edward IV, but they are thought to have been murdered on the instructions of their uncle, the Duke of Gloucester. He was determined to wear the crown and didn't want anyone spoiling it for him. By July 1483 they were declared illegitimate and the duke was crowned Richard III. In 1485, he was killed in the Battle of Bosworth and the victor, Henry Tudor, who was crowned Henry VII, is also a suspect in their disappearance.

Fifteenth-century guards passing the Bloody Tower saw shadows of two small figures gliding downstairs, dressed in the white nightshirts they were wearing when they vanished. They stood hand in hand, before fading into the wall. These figures were believed to be the boys' ghosts. Shortly after, workmen discovered children's' skeletons and, as they were thought to be the remains of the princes, they were given a royal burial.

Points for most persistent ghost goes to Queen Anne Boleyn, who was beheaded on Tower Green on 19 May 1536. The unfortunate queen has been seen near the Queen's House, close to the execution site, and occasionally leads a ghostly procession down the aisle of the Chapel Royal of St Peter ad Vincula. Spookier still, her headless body has been seen walking the corridors of the Tower.

Then there's explorer and adventurer Sir Walter Raleigh, famed for placing his cloak on the mud so that Elizabeth I could cross the road without getting her shoes dirty. He lived quite comfortably compared to others imprisoned within the Bloody Tower. He was assigned two second-floor rooms and lived there for thirteen years. The rooms are furnished as they were when he was there. He was freed to look for the lost city of El Dorado, but when he didn't come up with the goods was taken back to prison again. Although executed in Old Palace Yard at Westminster, visitors have reported seeing his ghost looking exactly as he does in his portrait in the Bloody Tower.

Something scary haunts the Salt Tower; something so terrifying that dogs won't enter the building. Prisoners here include Hew Draper, a Bristol innkeeper accused of

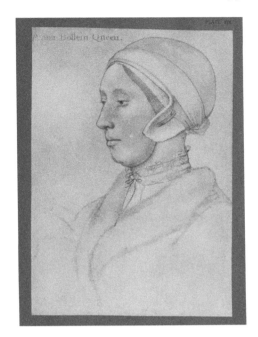

Above left: One of the Yeoman Warders, commonly known as 'Beefeaters'.
(© Britain on View)

Above right: Queen Anne Boleyn haunts the Tower of London.

Right: Salt Tower, Tower of London: a scene of torture and sorcery.
(© Historic Royal Palaces)

practising sorcery and it is where Jesuit priest John Gerard was tortured, suspended from chains on the dungeon wall.

Anne J. from Leeds visited the Salt Tower in 2015 and told me, 'I felt a frightening atmosphere and orbs appeared in several pictures I took.' She's not the only one to report mysterious goings-on, as Phil B. explains. 'I walked along the rampart leading to a doorway of the Salt Tower. The door was open. I felt a huge sense of dread and instantly felt something very bad connected to this Tower.'

Edmund Swifte, keeper of the Crown Jewels, lived in Martin Tower with his family. One Sunday in 1817 he and his family saw a column of a liquid-like substance drifting through the room. Swifte's wife said it tried to grab her but it disappeared when Swifte threw a chair at it. German spies were imprisoned and executed here during the First World War.

In 1864, a soldier whose post was to guard the Queen's House at the Tower, saw an apparition so lifelike that he charged at the intruder with his bayonet, only to go straight through the figure. He was found unconscious at his post and later court martialled for neglecting his duty. Luckily witnesses corroborated his story and the soldier was eventually acquitted.

The area where Henry VIII's armour was once stored has an evil reputation; stories exist of guards feeling threatened by an unknown force. The armour is now on display in the White Tower and to date there are no records of whether the force has also relocated.

And an interesting endnote to this report. Major General Geoffrey Field was governor of the Tower of London from 1994 to 2006. He and his family lived in the Queen's House on Tower Green. He said,

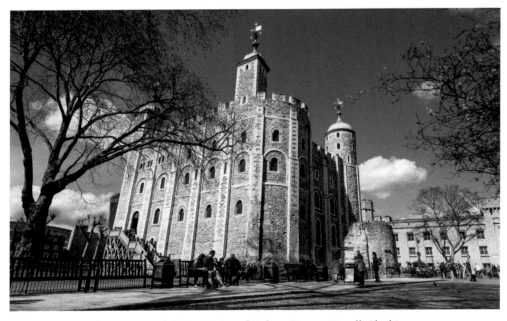

The imposing White Tower. (© Historic Royal Palaces/James Linsell-Clark)

Soon after we arrived in 1994, my wife Janice was making up the bed in the Lennox room when a violent push in her back propelled her out of the room. No one had warned us that the house was haunted but we then discovered that every resident has experienced something strange in that room. The story goes that the ghost is that of Arabella Stuart, a cousin of James I, who was imprisoned and then possibly murdered in that bedroom. Several women who slept there reported waking in terror the middle of the night feeling they were being strangled, so just in case, we made it a house rule not to give unaccompanied female guests the Lennox room.

Sensible decision.

Hampton Court Palace, East Molesey, KT8

Hampton Court Palace was one of Henry III's favourite residences. While it is not strictly in London, I've included it simply because it is a seriously haunted palace. His fifth wife, Catherine Howard, has been seen wandering restlessly through the rooms, as she probably did when she was there under house arrest after being charged with adultery. The story goes that she ran along the gallery to the chapel where the king was at Mass to beg his forgiveness. Before she could reach him, she was seized by guards and dragged screaming back to her rooms. Visitors have heard

Take a ghost tour at Hampton Court Palace. (© Southwest News Service/Historic Royal Palaces)

Learn more about supernatural happenings on a Hampton Court Palace ghost tour. (© Southwest News Services/Historic Royal Palaces)

her ghostly shrieks. In 1999 two female visitors fainted in the same spot as her screams have been heard.

Nurse Freda S. visited Hampton Court last summer with her two daughters. She told me, 'I'm certain I came upon Catherine Howard. It was in the Haunted Gallery. It's difficult to explain, it was a sensation of someone being extremely afraid. As a sensitive, I detect spirits as a kind of atmospheric blanket and this one came to me as if seeking my help. I felt terribly upset that I couldn't do anything to help her.'

Henry VIII's third wife, Jane Seymour, also haunts Hampton Court. She is still seen walking in the cobbled grounds of Clock Court. On the anniversary of the birth of her son, Edward, she ascends the stairs leading to the Silver Stick Gallery, dressed in a white robe and carrying a candle.

Buckingham Palace, SW1

Like many old buildings, Buckingham Palace has a phantom or two. There was a monastery on the site and one ghost is that of a monk who died in the punishment cell centuries ago. He wears heavy chains and is dressed in brown and appears on the terrace over the gardens to the rear of the building on Christmas Day. Another ghost reputed to haunt the palace is that of Major John Gwynne, private secretary to Edward VII. After his divorce from his wife, he was shunned by society. Unable to cope with a life of shame, he shot himself in his office on the first floor and has been seen and heard at various times by staff members.

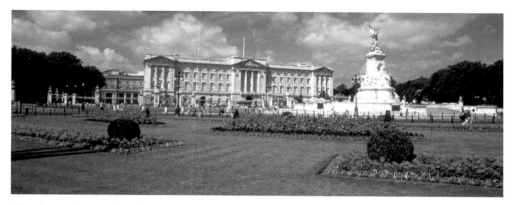

The ghost of a monk wafts round Buckingham Palace. (© Britain on View)

Kew Palace, Richmond, TW9

Kew Palace was a royal retreat for George III and Queen Charlotte, and served for a time as a sanatorium for the 'Mad King' during his bouts of so-called insanity. During one of these periods, he would insist on ending every sentence with the word 'peacock'. He even tried to open Parliament with a speech which began 'My lords and peacocks'. Sometimes he also wore a pillowcase on his head.

When Queen Charlotte became ill it was thought that a few days in the clean air of Kew would benefit her. Her daughter Princess Elizabeth wasn't impressed with the palace, saying it was damp and unfit to house her mother. The queen's condition

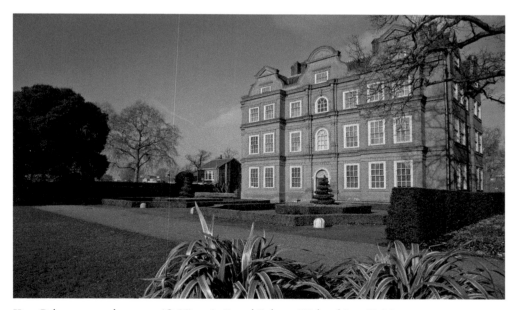

Kew Palace: a royal retreat. (© Historic Royal Palaces Richard Lea-Hair)

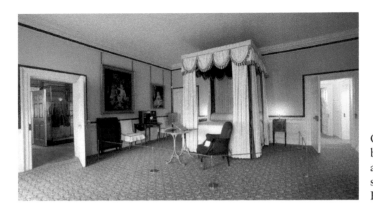

Queen Charlotte's bedroom in Kew Palace and the chair on which she died. (© Historic Royal Palaces)

deteriorated and she contracted pneumonia. During her last days she found difficulty lying down and was more comfortable sitting in what is known as 'Queen Charlotte's Chair'. She died in this chair at 1 p.m. on Tuesday 17 November 1818 surrounded by four of her family. The chair is on display. Sometimes, when dusk falls, a shimmering figure has been spotted sitting in the chair, disappearing a moment later.

'Witch marks' are carved on floors and in attics at Kew Palace to ward off evil spirits. When the palace was built people were particularly superstitious and believed that witches could enter homes disguised as cats or frogs and cast spells on people while they slept. To stop this, signs were carved beside windows, doors and fireplaces to protect occupants from evil.

Apparitions appeared to builders here several years ago. The first was described as 'something white', the second being 'somebody quite small wearing a long dress who appeared to be holding a candle'. This may be the spirit of Prince Octavius, who died at Kew in 1783. The explanation for the 'long dress' could be that at four years old he would not yet have undergone the rite of passage known as 'breeching', which would have occurred when he was about seven, so the little boy would have worn long skirts when he died.

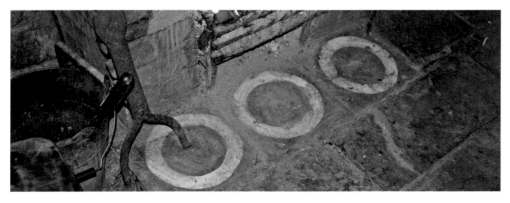

Witch marks that were carved by carpenters in days of old to ward off evil. (© Gilly Pickup)

Places of Worship – Churches, Cathedrals and Abbeys

Cathedrals, churches and other religious places can easily take on a haunted appearance. Hooded monks may look like ghosts as they glide along while spectres may lurk in sacred places.

St James Garlickhythe, Garlick Hill, EC4

In the vault of the Church of St James Garlickhythe, mummified remains of a man were discovered in the 1850s. Christened 'Jimmy Garlick', the mummy was put on display and Victorians paid to come and see him. He is still in the church, but hidden from prying eyes, thank goodness. Jimmy's ghost is said to protect the church, and during the Second World War a robed figure believed to be him was seen walking through the church before air raids. The church was one of the few to emerge from the Blitz unscathed.

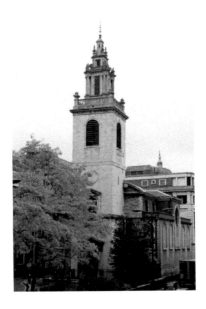

Church of St James Garlickhythe has a protective phantom. (Courtesy of Tony Hisgett under Creative Commons 2.0)

Pathway through St Magnus the Martyr Church. (Courtesy of Mike Peel, www.mikepeel.net, CC-BY-SA-4.0, under Creative Commons)

St Magnus the Martyr Church, Lower Thames Street, EC3

St Magnus the Martyr Church is said to be haunted by a figure thought to be the spectre of a Bible translator named Miles Coverdale. One witness described looking into the figure's hood and seeing no face. That is really scary. However, that is not the only ghost. A black-haired priest has been seen standing over the tomb of a former bishop. Much more horrid than these, and one you'd definitely not want to see, is the headless figure that has been reported at least once in the building.

Westminster Abbey, SW1

Father Benedictus is a spectral monk in Westminster Abbey and at the Tomb of the Unknown Soldier, a poignant memorial to the soldiers who died in the First World

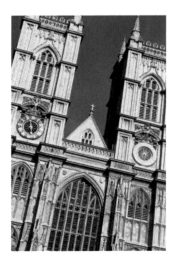

Westminster Abbey is haunted by a spectral monk. (© VisitBritain & Britain on View)

War, a ghostly military figure sometimes appears just as guests dissipate for the day. The spectre bows his head for a few moments before slowly dissolving into thin air.

St Bride's Church, Fleet Street, EC4

A tour of St Bride's Church takes visitors through its 2,000-year history. During an excavation of the site in the 1950s thousands of human remains, many victims of the 1665 plague, were discovered in the sealed-off crypt. A guided tour takes visitors into the charnel house in the crypt to see the bone collections.

St Paul's Cathedral, St Paul's Churchyard, EC4

The apparition of a minister with flowing locks has been sighted in St Paul's Cathedral's All Soul's Chapel in the north-west tower. He whistles sorrowfully while crossing the room and vanishes through the wall. Those who have heard the whistling say that it is exceptionally loud and upsetting for those who come to contemplate. St Paul's is also home to the bell Great Tom, which is said to strike prior to the death of a royal.

Go to St Paul's Cathedral and
you may hear the whistling ghost.
(© VisitBritain)

St Dunstan's Church, Friar's Place Lane, W3

Alongside white and grey ladies, the 'monk' has to be one of the most symbolic of ghostly legends in Britain. Such figures signify the peace and tranquillity of old abbeys and priories. Near St Dunstan's Church in East Acton a procession of hooded figures has been seen. They don't hang about though; those who have seen them say they disappear through a wall.

John Harries in his book, *The Ghost Hunter's Road Book* (published in 1968), wrote of the St Dunstan's ghosts: 'these ghosts are of too recent an origin for any traditional story to explain their haunting. Until a century ago it was a small village and noted for the piety of its inhabitants. In the seventeenth century it was a centre of Puritanical zeal; possibly the phantom monks were victims of persecution of their order.'

When a journalist visited the church one evening, he saw six ghostly monks who came towards him and walked through him. A voice told him there was a monastery nearby in the fifteenth century. When the newspaper photographer arrived he could see nothing, but two other witnesses said they thought they had seen spectral monks. An organist later recorded feeling an icy chill and said he saw something from the corner of his eye, 'a hooded figure, maybe a monk'. He went on to say, 'I don't believe in ghosts though.'

A parade of otherworldly monks visit the cloisters. (© Gilly Pickup)

St Bartholomew-the-Great, Smithfield EC1

The atmospheric twelfth-century church St Bartholomew-the-Great is the capital's oldest church. What's left of the priory was founded by a monk named Rahere who, it is said, before taking his vows was a court jester in the court of Henry I. He also founded the adjacent hospital. In the nineteenth century his tomb was opened by the authorities to see the state of the church founder's body. Everything was as it should have been. A few days later one of those who witnessed the tomb opening fell ill. Terrified of what was happening, he said that he had stolen one of Rahere's sandals from his body. He gave it back and got better, but sadly the sandal was never returned to Rahere. This is why it is said to be Rahere's ghost that loiters in the church, particularly around his own tomb and effigy. Witnesses declare that the figure of a monk appears before them before disappearing in a wisp of air. Other researchers disagree that the figure is Rahere and claim the phantom is a martyr burned in the area of Smithfield, not far from the church.

The church has appeared in films including *Four Weddings and a Funeral* and *Shakespeare in Love*. One night an alarm went off inside, waking verger John Caster. He went to investigate and heard footsteps but couldn't see anyone, so called the police. They searched the church with the same result. When engineers came next day to test the alarm they found that something had triggered a beam in the middle of the church, somehow not setting off other beams around it. Was it Rahere? Some believe so.

Yet another monk appears at St Bartholomew-the-Great, standing by the altar. Those who have caught a glimpse of him say he vanishes in a split second while another ghost has been seen in the pulpit, dressed in clothing from the Reformation period. St Bartholomew's is obviously a busy church when it comes to phantoms.

London's oldest church has plenty of creepy stories attached. (© Gilly Pickup)

All Hallows-by-the-Tower Church – will you see the spectral Persian cat? (Courtesy of Mark Ahsmann under Creative Commons 3.0)

All Hallows-by-the-Tower, Byward Street, EC3

Located next to the Tower of London, All Hallows-by-the-Tower has cared for numerous beheaded bodies brought for temporary burial following their executions on Tower Hill, including those of Thomas More, Bishop John Fisher and Archbishop Laud.

The church suffered extensive bomb damage during the Second World War, with only the tower and walls remaining, and it was then that the ghost of a Persian cat was first seen. It isn't only humans who return in ghostly form after death, spectral animals are pretty usual too. This phantom feline haunted the original church prior to destruction by German bombers, and in one story a group rehearsing Christmas carols claimed to have seen a phantom woman sitting on a chair. The figure disappeared and was replaced by a black cat that also vanished soon after. The church was rebuilt after the war and was rededicated in 1957.

You could spot a long-dead monk near his own effigy. (© Gilly Pickup)

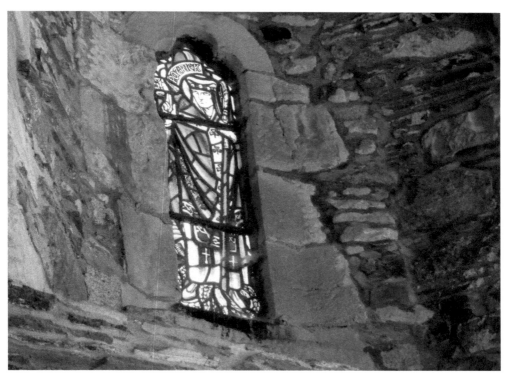

Sir Thomas More's body lay in this church before burial. (© Gilly Pickup)

CHAPTER NINE

Theatres

Look out behind you…

Thespis of ancient Athens holds a place of privilege in theatre lore. According to some historians, Thespis was the first person to speak as an individual actor on stage. This is where the term 'thespian', referring to an individual actor, comes from. Thespis is likely to be blamed for unexplainable mischief that befalls a production, especially if it happens on 23 November, the date he supposedly uttered the first lines.

Theatreland – heart of the world's theatre. (© Gilly Pickup)

Victoria Palace Theatre – look out for the naughty poltergeist! (Courtesy of Carlos Delgado, CC-BY-SA, under Creative Commons 3.0)

Victoria Palace Theatre, Victoria Street, SW1

The Victoria Palace Theatre is a handsome building, its grey marble foyer adorned with gold mosaic and white Sicilian marble pillars. It is home to a naughty poltergeist who likes to give guests a hair-rising experience. Quite literally. This spirit seems to have a fetish for wigs because hairpieces have been reported to fly through the air for no apparent reason. So if you visit this theatre and your hair is not your own, all I can say is be careful, and don't say I didn't warn you…

Queen's Theatre, Shaftesbury Avenue, W1

Another lighthearted spirit haunts the Queen's Theatre in Shaftesbury Avenue, possibly London's only theatre to have a gay ghost! In 1913, the theatre held 'tango teas'. These cost 2s and sixpence and people could have a lovely time dancing and enjoying afternoon tea. There is the chance that this naughty spirit comes from this

time. Male staff who work here have had feelings of being ogled as they change into their uniforms before a performance. There have also been reports that some of them have had their bottoms pinched by an invisible presence!

Duke of York's Theatre, St Martin's Lane, WC2

Violet Melnotte, known as 'Madame', was the first proprietor of the Duke of York's Theatre, the first of three theatres to open in St Martin's Lane in the early 1890s. At the time, it was called the Trafalgar Theatre. Violet enjoyed watching performances from her own box and after she died in 1935 continued to do so. Violet sometimes appears in the dress circle bar, arriving as a wispy white mist that develops into a shape. Is she trying to communicate or is she just letting staff and actors know she is still there?

But the theatre harbours something much more frightening than Violet. In the 1940s, it was the setting for the macabre 'Strangler Jacket' incident. The jacket, borrowed by the wardrobe department from the old Embassy theatre, was seriously scary. Actresses who wore it during a production of *The Queen Came By* complained of feelings of constriction and suffocation. It was almost as if this black bolero was trying to squeeze them to death. During fittings, late actress Thora Hird had no problems with the jacket, but once the show was underway she said she felt the garment growing tighter.

Duke of York's Theatre originally called the Trafalgar Theatre. (Courtesy of Andreas Praefcke under Creative Commons 3.0)

The no-nonsense wife of the play's producer didn't believe the allegations and wore the jacket to prove there was nothing wrong with it. Huffily, she took it off saying, 'I knew it was rubbish, tales of ghosts – stuff and nonsense' and handed it back to the dresser, whose face was rigid with fear. Turning to the mirror, the disbeliever was horrified at the sight of angry red marks covering her neck as if something invisible had tried to strangle her.

At a séance to try and get to the root of the problem, sitters contacted the spirit of the actress who first wore it. She said that her boyfriend strangled her then removed the jacket before throwing her body in the river. It is almost as if the loathing the man felt towards her, as well as the method of killing, were absorbed into the jacket's fabric, so affecting those who have worn it since.

Where is the jacket now? British parapsychologist Peter Underwood discovered that it was sold to an American collector whose wife tried it on and immediately found it tried to strangle her too. Whether they kept the offending garment is not on record. One would think it is probably unlikely.

And finally, as if this theatre isn't scary enough, something else unworldly happens here. Actors and staff have heard an iron fire door slamming shut, though the door in question is no longer there. An antique key once materialised out of thin air where the door used to be and fell at the feet of the then theatre manager. Scary stuff.

Her Majesty's Theatre, Haymarket, SW1

Perhaps the reason so many theatres are haunted is because actors are required to be intuitive and imaginative. Many are also superstitious.

Although Andrew Lloyd Webber's long-running *Phantom of the Opera* plays in Her Majesty's Theatre, that is not the only phantom associated with this theatre. Constructed in 1897 for RADA founder and actor-manager Sir Beerbohm Tree, he often

The long-running
Phantom of the Opera
at Her Majesty's
Theatre, Haymarket.
(© westendmediacentre.com)

Left: A plaque for founder and actor-manager Sir Herbert Beerbohm Tree at Her Majesty's Theatre. (© Mike Pickup)

Below: Her Majesty's Theatre, home to countless spirits. (© Mike Pickup)

comes back to haunt the building. In his lifetime, he liked to watch performances from the top box, stage right, and this is the centre for manifestations reported today. Occupants sometimes complain of cold spots and say that, occasionally, the door to the box opens of its own accord as if allowing access to someone invisible. If Sir Herbert is responsible, he does not restrict his activities to this area.

In the 1970s during a performance of *Cause Celebre*, the cast, including actress Glynis Johns, saw a spectral figure glide across the theatre behind the stalls and disappear. A fickle phantom. There was no doubt in the minds of those who saw him that it was Sir Herbert. There are also rumours that legendary comedian Tommy Cooper still wanders around Her Majesty's after his death on stage here in 1984. Broadcast live on television, millions saw Tommy fall behind the curtain and die 'just like that'.

Theatre Royal, Haymarket, SW1

It seems that actor-managers like to keep an eye on things in their theatres even after they are no longer alive. Acclaimed nineteenth-century performer John Baldwin Buckstone visits Dressing Room 1 (his own) at the Theatre Royal Haymarket. A friend of Charles Dickens, Buckstone wrote and performed mainly comedies and

Theatre Royal, Haymarket, has a 'good omen' ghost. (© Visit London images/ Britain on View)

farces. Although he has not been in this world for many years, staff have heard a man's voice rehearsing lines in his former dressing room. Of course, on opening the door, the room is empty.

Waiting for Godot opened on 30 April 2009 with Sir Patrick Stewart and Sir Ian McKellen in the lead. Their performances were the subject of a documentary series called *Theatreland*, produced by Sky Arts. The *Daily Telegraph* reported that Patrick Stewart saw Buckstone's ghost. Coming off stage for the interval, Sir Ian asked him, 'What happened, what threw you?' 'I just saw a ghost. On stage, during Act One,' Stewart replied. He told his co-star that he also saw the apparition in the wings wearing a beige coat and twill trousers. The episode was related in the documentary produced by the television channel, though cameramen failed to capture images of the phantom.

Nigel Everett, a director of the theatre, said, 'Patrick told us about it. He was stunned. I would not say frightened, but I would say impressed.' Appearances of Buckstone were not that frequent, Mr Everett said, the last being by a stage hand some years before.

He added: 'The last time an actor saw him would have been I think Fiona Fullerton, playing in an Oscar Wilde some years ago'. The ghost tends to appear when a comedy is playing.' While he said he did not consider *Waiting for Godot* to be a comedy, he thought their production had comic aspects. 'I think Buckstone appears when he appreciates things,' he added. 'We view it as a positive thing.'

Dame Judi Dench and Sir Donald Sinden have also seen the phantom. The latter saw him when he was playing in *The Heiress* with Ralph Richardson in 1949. Buckstone is considered a good omen. The productions he visits are blessed with luck and a long run.

Theatre Royal, Drury Lane, WC2

There is another Theatre Royal, this one in Drury Lane, which also has its fair share of ghosts. One is Joseph Grimaldi, performer and clown, who still takes spectral curtain calls. The character, who wore an oversized harlequin suit, became so popular that clowns are still referred to as 'Joeys' in his honour. Grimaldi's last request – gruesome in the extreme – was that his head be severed from his body before burial, which might account for his disembodied white-painted face having been seen watching a show from a box. It scares the wits out of those who turn to find the disembodied head suspended in mid-air behind them. Grimaldi is not the only spectre treading the boards at this theatre, though, London's oldest working theatre reputed to be the world's most haunted.

The show *Oklahoma* is obviously appealing to those in the spirit world because in 1948, during the show's run, a ghostly Charles II and several of his courtiers appeared on stage for a few seconds. They were seen by several actors and members of the public.

The Theatre Royal was opened during the reign of this king, who loved theatre, possibly because his favourite mistress – Nell Gwynn – was associated with it from the time she sold oranges in the pit. Charles II also overturned a ban preventing women

Theatre Royal Drury Lane, haunted by Joseph Grimaldi, performer and clown. (© Gilly Pickup)

from performing on stage. It is likely he did this to please his mistress, because she was quickly promoted from orange seller to actor appearing on stage despite the fact that she could not read or write. Her last original character was Almahide in Dryden's *Conquest of Granada*. She spoke the prologue to this play in a straw hat described as 'large as a cartwheel'. Charles II was present and was convulsed with laughter, but whether the mirth was due to the hat or Nell's acting we don't know.

Famed for supernatural shenanigans, the theatre is home to a flock of phantoms, including Dan Leno, former pantomime dame who went mad before his death in 1904. Actors and stagehands have been haunted by Leno's signature aroma of lavender – he used the scent to cover up his incontinence problem. One of those who saw Leno's ghost was actor Stanley Lupino, who insisted that he saw the phantom in his dressing room. The caretaker assured him that there was no one else near his dressing room. However, shortly after when Lupino was again in his dressing room, he looked in his mirror and was horrified to see, next to himself, Dan Leno's face. A few months later, Lupino was in the same room with his wife when they saw Leno appear. This was the last dressing room that Leno used in his lifetime. This story was related by late comedian Arthur Askey to paranormal investigator Peter Underwood. Askey had no doubt that Lupino had the experiences he described.

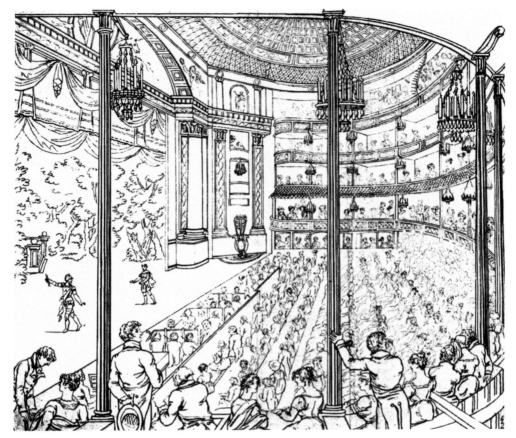

Theatre Royal Drury Lane, 1813. (Courtesy of Bishonen, scanned from the Survey of London, Volume 35, The Theatre Royal Drury Lane and the Royal Opera House Covent Garden)

Another of the Theatre Royal's apparitions is the 'Man in Grey', who wears a powdered wig, tricorn hat, ruffled shirt, riding boots, grey riding cape and carries a sheathed sword. He sits in the end seat of the fourth row of the central gangway in the upper circle for some time before getting up and walking through a solid wall. He generally appears during rehearsals, so has been witnessed by countless people. Ghost hunter J. Wentworth Day reported seeing a moving blue light in the theatre in 1939 that he attributed to the Man in Grey. Who was he in life? Probably actor Arnold Woodruff who was murdered around 1790 and whose skeleton was found by builders during renovations in the 1870s when they broke down the wall he now walks through. They found a skeleton, a knife protruding from its ribs and shreds of grey cloth hanging from the bones.

In 1939, the cast of Ivor Novello's *The Dancing Years* were gathered on stage for a photo call when the Man in Grey appeared before them. More than half the cast saw him. However, despite his bloody end, this ghost brings only luck as he appears at the beginning of a successful run.

The Coronet, Notting Hill Gate, W11

I knew the couple who owned the Coronet theatre at Notting Hill Gate. The lady was the owner, she owned a group of cinemas, while her husband had fingers in many pies and often had lunch with the late Queen Elizabeth, the Queen Mother. I was working on a project there for him in the early 1990s and had a small office behind the 'gods'. My work meant that I sometimes arrived before anyone else so that I was in the building alone.

The cinema was originally a theatre and first opened its doors in 1898. It was frequented by Edward VII and many famous stars of the day, including Ellen Terry and Sara Bernhardt, trod its boards.

One Coronet ghost is that of a cashier who was overcome with guilt at being caught stealing from the till and threw herself over the theatre's balcony to her death. Many people have come into contact with her, as did I. A few times, early in the morning when there was no one but me in the building, I have heard her running upstairs to the balcony and twice saw a vision in a long dress, a vague shape that vanished almost as soon as I set eyes on her. I was not afraid when I saw or heard her; her aura is one of sadness, but I felt she is a friendly spirit.

London Coliseum, St Martin's Lane, WC2

Since the end of the First World War in 1918, the London Coliseum has played host to the spectre of a soldier who spent his last night of leave at a performance before being killed in action. After his death, people saw a man they recognised walking down an aisle in the theatre. He looked like a real person, quite solid, so they were spooked when they saw him vanish in front of them. The entity, dressed in soldier's uniform, has been seen in the same area several times since on the anniversary of his death, 3 October.

Coliseum Theatre, St Martin's Lane, where a spectral soldier returns on his anniversary. (© VisitBritain/Pawel Libera/British Tourist Authority/additional credit Society of London theatre)

Lyceum Theatre, Wellington Street, WC2

Now we come to the Lyceum Theatre, which it seems contains an 'energy vortex' that may function as a porthole for spirits to pop in and out of dimensions. Well, so some say. Whether or not that is the case, I'd advise you to have all your senses in gear when visiting. There is just a small possibility that you will see something that will freak you out.

A phantom of an elderly woman sits in the stalls cradling a severed head in her lap. Who is she and whose head does she hold? Some say that she is the spirit of Marie Tussaud, who exhibited her waxwork creations for the first time in the theatre in 1802, and that the head is a wax model – maybe.

One sighting was during the 1880s, when a couple watching a play happened to glance over the balcony and saw the severed head grinning up at them from a woman's lap. Blood-curdling indeed, but they obviously lived to tell the tale because some years later they visited a house in Yorkshire and saw a man's portrait, his head still attached to the rest of him. They recognised the face as that of the severed head they had seen years before in the theatre. The owner of the house explained the man in the painting was an ancestor, Henry Courtenay, Marquess of Exeter, who once owned the land the Lyceum stands on and who was beheaded by Cromwell. Spooky or what?

Above left: Lyceum Theatre, which has an 'energy vortex'. (Courtesy of The Lud)

Above right: Stage door on a quiet day. (© Mike Pickup)

Actress Ellen Terry has also been known to put in the odd ghostly appearance here; she played here for over twenty years up until her death. When she appears she wears a green dress, which she wore when playing Lady MacBeth in 1888. The dress itself is famous. Made from 1,000 iridescent wings of the jewel beetle, which the insects naturally shed as part of their life cycle, it was restored at huge cost and was on display at the Costume Gallery in her home in Smallhythe Place, Kent, now owned by the National Trust. The cost of its restoration and display was met by donations, most from visitors to the house where she died in 1928.

Dominion Theatre, Tottenham Court Road, Fitzrovia, W1

It's all about the beer at the Dominion Theatre, Tottenham Court Road. Well, it used to be anyway, because the theatre is built on the site of the Meux Brewery, where in 1814 a vat burst and 3,550 barrels of beer covered the area, with eight people losing their lives. This beer tsunami destroyed two houses and the wall of the Tavistock Arms pub in Great Russell Street. One of those who died was fourteen-year-old barmaid Eleanor Cooper, and it is thought that she is one of those who haunts her former workplace.

Theatregoers have reported strange sensations in the theatre, including sighting a ghostly figure lurking in the wings. Occasionally sounds of giggling children filter through empty dressing rooms, while reports of poltergeist activity involving objects

Phantoms lurk in the wings. (© Gilly Pickup)

Audience participation – I wonder if the resident poltergeist joins in. (© Gilly Pickup)

that disappear before reappearing elsewhere send a shiver down the spine. Carrie G., who visited the theatre early in 2017 with her family, told me that halfway through the performance she felt someone tapping her arm. 'No one was there,' she told me, 'but I definitely felt something. When we got up to leave, something tried to push past from the front and I felt a cold chill. Again, nothing was visible.'

* * *

Next time you visit one of London's marvellous theatres, don't worry if you feel, see or hear something that is not quite of this world we live in. A resident ghost – or two – in a theatre is a sign of good fortune to all who encounter it/them.

CHAPTER TEN

Underground London

Tunnels and Tube stations can be creepy places, especially in the dark and when there's no one else around…

Greenwich Foot Tunnel, SE10

In 1902 the Greenwich Foot Tunnel below the River Thames was opened to give easier access for dockworkers from Greenwich to the Isle of Dogs. It replaced an intermittent, relatively expensive ferry service. If you suffer from claustrophobia, it might be wise to give this tunnel a miss; even if you don't, some sensitive people feel uneasy when walking through here, as if they are being followed. Jess P., a trainee management consultant, had a story to tell me about walking through the tunnel:

> It was a November evening and beginning to grow dusk. There were a few other people around so I didn't feel worried about walking through the tunnel. I'd only gone a few yards when I saw a couple coming towards me. There was nothing really unusual about them, they were in their thirties or thereabouts and warmly dressed. She wore black button boots and a grey cape. Trendy, I thought. They passed by without looking at me and at the same time, I was almost blinded by a sharp flash of light. I turned round and nearly died of shock – they had vanished!

She paused and I could see that speaking about the incident spooked her. 'I mean, there are some people I've told think I'm nuts – but that's what happened. I can't explain it at all. Her clothes that I thought were modern could have been from a past century. One thing's certain, I won't walk through that tunnel again!'

At the end of December 2016, nineteen-year-old Liz Pointer went to Greenwich to visit a friend. She takes up the story:

> It was around 5pm we walked into the tunnel. There was nothing scary there, though we had both heard stories about it being haunted. We reached the middle and it was then I felt as if someone was following us, though there was no sound of footsteps.

Dome of Greenwich Foot Tunnel entrance. (© Pawel Libera/ Visitlondon.com)

I felt a cold blast of air on my left shoulder and totally freaked out. My friend said she sensed there was something there, though did not feel anything. We started to run until we reached the exit. No way will I go back there again.

Jacqueline Travaglia, owner of Lantern Ghost Tours (www.ghost-tours.com), also had a flesh-creeping story to share about the Greenwich Foot Tunnel:

It was in February 2017 and I was taking a tour group through the tunnel in the evening. I knew that bodies had been moved to build the tunnel and I pulled out a set of dowsing rods to make contact. I gave them to a female guest and the rods immediately started to move on their own to her surprise. The spirit of a little girl was communicating with us. A few group members said they felt what they describe as fingers wrapping around their hands. We asked the little girl to flicker the lights in the tunnel and she did. She then vanished and stopped communicating. She said she was eight years old and a happy spirit who used to live in the area but was not buried there.

Blackwall Tunnel, East London, E14

Another spooky tunnel is the Blackwall Tunnel, believed to be haunted by a young man who was killed in a motorcycle accident in the 1960s. Sometimes he appears in front of motorcyclists, frantically flagging them down and asking for a lift to

Leigh-on-Sea in Essex. Those who have taken him on the pillion say that he vanishes a few miles into the journey.

One of those who stopped to pick him up held a conversation with him and the man told the driver where he lived. Coming out of the tunnel, the driver turned briefly to make a comment only to find his passenger had disappeared. The driver turned back and went through the tunnel again but found no sign of his passenger. He was so shocked that he drove to the address his passenger had given him, where he was told a man of that description had lived there several years previously but had died.

Bethnal Green Tube Station, E2

London Underground has always been enormously important to Londoners and was probably particularly so during the Second World War. Stations and stairwells offered refuge from the Blitz that tried to bring London to its knees.

If Bethnal Green Tube station is on your daily commute, maybe you have heard the ghostly screams that seem to emanate from nowhere. In the Second World War

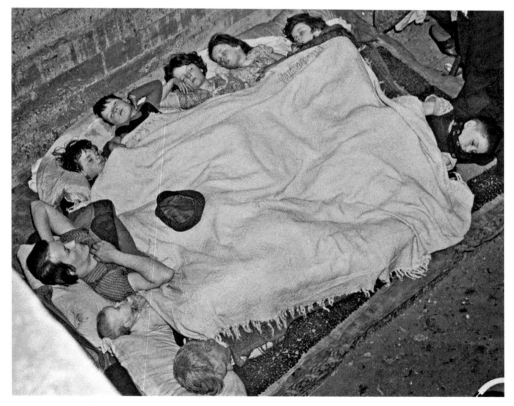

A Second World War air-raid shelter in an Underground station. (Courtesy of the US National Archives and Records Administration)

What would London be without its Tube stations? (© Mike Pickup)

this underground station was used as an air-raid shelter, and in 1943, 173 people were killed during an air-raid test. The siren caused mass panic as people fled to the supposed safety of the Underground, fearing bomb strikes. Investigations confirmed that 126 women and children were among those killed. Station staff have reported hearing the sound of children sobbing together with female voices and screams. Passengers, too, have reported hearing cries in the station passage ways.

Bank Station, EC3

Shortly after Bank station opened in 1898, people said that it was haunted by a nun. Research showed that she was probably Sarah Whitehead mourning the death of her brother, bank clerk Philip Whitehead. He was arrested and hanged for forging cheques in 1811 in the nearby bank, which gave the station its name. The news drove his sister Sarah mad and every day for the rest of her life she visited the bank and asked to see her brother. As she always did this in mourning dress, staff nicknamed her the 'Black Nun'. Sightings are always accompanied by a wave of sadness and a foul smell.

This was also where fifty-six people were killed in the booking hall when a bomb hit the station in 1941. There are also rumours of a mass grave for seventeenth-century plague victims beneath the station – perhaps the 'foul smell' is associated with that.

King's Cross Station, Euston Road, N1

Although it is one of London's busiest Tube stations, a phantom woman has been spotted at King's Cross. Described as young with long brown hair and dressed in modern clothing, she appears screaming with outstretched arms. She looks so real

Mind out for ghosts in the Tube. (© Gilly Pickup)

that people have run to help her, but when they do she disappears. The first sighting was in 1988, when a commuter saw a woman appearing distressed and walked over to comfort her, only to pass right through her when he reached her. Since then there have been reports of similar sightings at the same spot. The King's Cross fire in 1987 may be the cause of these incidents; she may have been one of the thirty-one victims.

According to local lore, Boudica, Queen of the Iceni, is buried between platforms 9 and 10. Yes, Harry Potter and Platform 9 ¾ springs to mind, but apparently that is a coincidence. Boudica's ghost is said to haunt the tunnels beneath the station.

Farringdon Station, Cowcross Street, EC1

A spooky figure has been seen at Farringdon station. Known locally as 'the Screaming Spectre of Farringdon', she is believed to be the ghost of a twelve-year-old girl who was murdered by her eighteenth-century workhouse employer. Research shows she may be apprentice milliner Anne Naylor, whose body was thrown into nearby sewers.

Aldwych Station, Strand, WC2

Aldwych Tube station was built on the site of an old theatre, the Royal Strand, which stood here until 1905. Although no longer used as an Underground station, it has

Strand station, now mainly used for exhibitions. (© Mike Pickup)

The British Museum stored its treasures in the Underground. (© Visit London Images/Britain on View)

occasionally been used for *The Battle of Britain* (1969), *Superman IV – The Quest for Peace* (1986), *The Krays* (1990), *Patriot Games* (1992), *Mr Selfridge* (2013) and *V for Vendetta* (2006). The station façade was also used as a base location in the BBC Three documentary series *Spy*. It is sometimes used for exhibitions too.

During the Second World War it was used as an air-raid shelter and to store national treasures from the British Museum, including the Elgin Marbles. It was reopened after the war but closed on 30 September 1994, when the cost of lift refurbishment was deemed uneconomic.

The station, which reverted to its former name the 'Strand', is haunted by an actress who trod the boards in the theatre that stood here. Over the years station workers claim to have seen her agitated presence late at night, wandering the station's deserted platforms and eerie tunnels. Those who have seen and felt her appearances say they are preceded by an 'inexplicable atmosphere of oppression'.

Moorgate Station, Moorgate, EC2

Passengers at Moorgate station in the 1970s reported seeing a man in blue overalls who adopted a look of absolute horror before vanishing into a wall. The story has been linked to the Moorgate Tube crash of 1975, in which many died. Some paranormal enthusiasts suggest that if the crash driver saw this ghost then that could have been the cause of the accident, the reason for which has never been found.

Underground station sign. (© Transport for London)

Liverpool Street Station, EC2

In 1247 it was founded as the Hospital of St Mary of Bethlehem and in the 1400s it began admitting patients, referred to as 'lunatics'. This psychiatric hospital was dreadful and its treatment of patients so horrible that its name is the origin of the word 'bedlam'. Patients were kept in filthy conditions, often chained and sometimes displayed for members of the public to look at for a fee. Nowadays this is the site of Liverpool Street station – no wonder it is haunted by unquiet souls who suffered so terribly in days of yore. Around 3,000 bodies from the hospital were buried in the hospital's cemetery between 1569 and 1728. One ghost who still haunts the station is that of poor Rebecca Griffiths, a psychiatric patient. She comes back to look for a coin that she always held onto while she was in hospital, but sadly was buried without it. Rebecca won't rest until the coin is returned to her.

Liverpool Street rail station, where a psychiatric hospital once stood. (© Cultura Creative 2012/ London and Partners/Visitlondon.com)

Elephant and Castle Station, SE1

Footsteps and chattering have been heard by staff in Elephant and Castle station when it is closed, but no one, or nothing, is ever found. There is also a story that says the last train of the night is haunted by a girl who walks from the last carriage to the front and disappears as she reaches the engine.

Kentish Town West Station, NW1

James Williams from Spectrum Paranormal told me an intriguing tale about disused Kentish Town West station:

This was our second public investigation of the disused underground station. Our group was made up of fifteen members of the public, four station staff as well as five Spectrum team members. We started the evening with a group séance to build up and create an energy to make contact with the spirit realm. During the séance, we formed a circle and held hands to reduce interference from the public on our investigation. Hazel, our head of investigations, then asked a series of closed questions looking for an intelligent response that was regarded either as audible, visual or physical. It didn't take long for us get a response! Hazel asked if there were any spirits present in the room. She asked this spirit to knock or make a sound. Bear in mind, we were in the remains of an old lift shaft made of solid steel and concrete. We heard two distinctive audible knocks that sounded like they were on wood, which was near

impossible considering the circumstances. All participants were stunned and this was to be the turn of the events that would unfold throughout the evening. The events that preceeded this included a member of the public becoming overwhelmed by a spirit energy which she described as male. She was taken outside by a member of our team and was violently sick. She told Hazel afterwards that she was taken over by a male spirit; she had never experienced anything like this on any other paranormal events she had participated in.

As well as this, Hazel, James and Dean conducted a number of experiments throughout the evening – all obtained positive results. However, the most compelling occurrence of the evening happened during the last experiment. A small group were accompanied by Dean and Hazel into one of the hallways. James told me,

> Used in this experiment were both of our K2 metres and EMF Cell sensor. The aim was to gather a visual response, using colours on the devices as indications to question answers. Red would indicate 'yes', the strongest response that could be recorded, indicating a large amount of energy considered unlikely to occur naturally without a stimulus. Each device was given to a group member, those that were considered sceptics, to assure them we had no influence over the devices. Our focus was gaining knowledge of the spirit entity reported to haunt the location. Hazel told the spirit that she needed the devices to flash red to indicate their presence in the room. The metres flashed instantly after the demand was made. Hazel requested that the spirit repeat this in response to the questions that she would ask. Each option was given separately and the spirit given several seconds to respond.
>
> Q1: Are you a man, woman or child? **Response:** lights flash red for child, a young girl.
> Q2: Are you the young girl that sings? **Response:** lights flash red.
> Q3: Tell us how old you are (we would count from one to ten and the spirit would flash red on the number that best represents their age. This was asked three times). **Response:** Lights flash red for nine every time.
> Q4: Were you here during the war? **Response:** yes.
> Q5: Were you here during the First World War or the Second World War? **Response:** The First World War.

Once we felt that we had established a connection, Hazel was eager to find out more. She asked, 'So you are nine years old?' Only seconds later Dean and a member of the public reported hearing a disembodied voice that resembled that of a young girl. Reviewing footage, you can clearly hear a 'yes' response evident on the film captured that night. In twenty years of investigating, this remains one of the most compelling pieces of evidence we have obtained.

The video link showing the team's evidence is here:
 https://www.facebook.com/SpectrumParanormalInvestigations/videos/1363967193716146/

CHAPTER ELEVEN

Various

This section includes places that couldn't be categorised in a separate section. There is a bank, the O2 Arena, the *Cutty Sark*, Heathrow Airport and various other things including a mirror, books and a clock.

Millennium Dome (O2 Arena), Greenwich Peninsula, SE10

The Millennium Dome (the O2 Arena) was built on the site of the South Metropolitan Gas Works Company. Some office workers said it was haunted by the company's former chairman, Sir George Livesey. After the gas works closed for the last time, his

O2 dome entrance is haunted by a former company chairman. (© Pawel Libera/London & Partners/Visitlondon.com)

ghost was seen roaming the derelict site and sightings became more frequent when building work started on the Millennium Dome.

Coutts Bank, The Strand, WC2

Coutts Bank in the Strand is London's largest private bank and has as its most illustrious client, Her Majesty Queen Elizabeth II. A bank is probably one of the last places you would expect to find a ghost, but in November 1993 the directors took the extraordinary step of calling on the services of psychic medium Eddie Burks. They hoped that he would be able to lay to rest the phantom making a nuisance of itself in the computer room. Burk's amazing psychic powers made news headlines when he did just that.

A bank spokesperson told *The Times* newspaper that staff had reported 'strange happenings … like lights going on and off'. There were also reports of an apparition described as 'a shadow' that appeared from time to time. One unfortunate employee must have been scared witless when the ghost appeared before her – minus a head!

A séance was held and the medium made contact with the restless, troubled spirit. He was Thomas Howard, 4th Duke of Norfolk (1538–72), whose plot to marry Mary, Queen of Scots and depose Elizabeth I in Mary's favour resulted in his execution. 'I was beheaded on a summer's day,' the dejected duke apparently informed Burks. 'I have held much bitterness and … I must let this go. In the name of God, I ask your help.'

Coutts Bank, London's largest private bank. (© Mike Pickup)

Arundel House, town residence of the Howards and dukes of Norfolk. (Courtesy of Wenceslaus Hollar under Creative Commons 1.0)

Eddie Burks was able to persuade the spirit that the time had come for him to depart, and on 15 November 1993 a congregation that included the present Duke and Duchess of Norfolk gathered at the nearby Catholic Corpus Christi Church, Maiden Lane, Covent Garden, to say prayers for the repose of his soul.

On leaving the service the present duke was asked by a reporter if he was glad that his ancestor was finally at rest. 'Actually,' came the dismissive reply, 'I don't believe in ghosts.'

Footnote: Why would Thomas Howard haunt that part of the Strand? Research did not provide me with a definitive answer through Arundel House, originally the town house of the Bishops of Bath and Wells, later in the possession of the Earls of Arundel etc later in the possession of the earls of Arundel, which stood on the Strand until it was demolished in 1678. Arundel House came to the Duke of Norfolk from the Earl of Arundel by the marriage, which united the Fitzalans and the Howards. This was the town residence of the Howards, earls of Arundel and dukes of Norfolk. Thomas, 4th Duke of Norfolk, would have stayed here from time to time.

Objects

Read this and you may never look at that picture on your wall the same way again, and watch out for those books on the paranormal you keep in that bookcase.

Mirror, Muswell Hill, N10

In a Muswell Hill flat, a walnut-framed mirror started causing trouble for the occupants. Sotiris C. and Joseph B. found it in a skip and thought it looked exactly right to complement their furnishings. They painted it silver and hung it on the wall.

Soon afterwards, they began to have nightmares and woke up with scratches on their bodies. They also experienced random pains and saw shadows in the mirror. The young men were so distressed they decided to get rid of it. Perhaps someone was murdered in sight of the mirror, or maybe it's because mirrors are a window in an alternative and spiritual world. While thinking about spooky mirrors, there's a superstition that warns people not to look into a mirror at night or by candlelight as they may see demons or omens of death.

Footnote: The boys sold the mirror on eBay for £100. They didn't hide the problems they had encountered since acquiring it and included all the creepy happenings in their listing. Good for them.

Would you believe this mirror is haunted? (© Gilly Pickup)

Books can
be subject to
paranormal
activity too.
(© Gilly
Pickup)

Books, Senate House, Bloomsbury, WC1

Bloomsbury's Senate House houses the University of London's main library. The eighth floor of the imposing art deco building has over 13,000 books dedicated to the occult, a collection gifted to the library by paranormal investigator Harry Price in 1948. Since the books arrived staff have reported strange activity on this floor, including whispering when no one else is around, books floating off the shelves and sighting apparitions.

Clock, Red Lion Passage, WC1

There is a creepy clock in the Dolphin pub in Red Lion Passage. The hands have not moved since a Zeppelin bomb almost destroyed the pub in the First World War. Although the mechanism remains forever stuck at 10.40 p.m., the eerie clock can be heard to tick on quiet nights. On 8 September 1915, German Army airship L13 appeared in the night sky above London. As it sailed over the streets, its commander ordered the crew to release its deadly bomb cargo. One hit the Dolphin Tavern, rendering it into not much more than a heap of rubble. Three customers were killed. The time? 10.40 p.m.

Mahogany Cabinet, Acton

Anne Bowes, a teacher in Acton, inherited a roomful of grand furniture and furnishings from a lady she had been kind to over many years. The lady was from a Scottish noble family with royal links. One item Anne inherited was an intricately carved mahogany cabinet containing a silver tea set. Anne recalled,

Who knows what haunts this creepy cabinet. (© Gilly Pickup)

The first night that the cabinet was in my home, after hundreds of years spent in aristocratic surroundings, I saw its door open as if being pushed from the inside. For some reason, I didn't think much about it, just got up from the chair and closed it. Around half an hour later, the same thing happened again. I went to have a closer look and decided there was no reason for it to open by itself. I closed it as tightly as I could, though felt a shiver run down my back.

After I was in bed that night I heard what sounded like tinkling laughter coming from downstairs. Then I heard the unmistakeable sound of the mahogany cabinet's door creaking open. I got up to see the cabinet door open, the silver tea set spread around it on the floor. Next morning, I contacted a furniture removal firm to take away the cabinet and teaset. It was worth a lot of money, but I was so relieved to get rid of them.

Transport – Boats and Planes
Heathrow Airport, TW6

On the face of it, it is an unlikely location for a ghost, but Heathrow Airport has two phantoms. One was a passenger on an ill-fated flight from Brussels to London on 2 March 1948. The Sabena Douglas DC3 Dakota OO-AWH encountered poor visibility at Heathrow and crash-landed on runway 2-8-right, killing all three crew members and seventeen passengers. After the accident, emergency workers were

looking for survivors in the wreckage when a man wearing a trilby came up to them and asked if they had found his briefcase. According to onlookers, he then vanished. The man's body was later found in the wreckage. Since then there have been reports of runway sightings of the same man. If you're in one of the airport's VIP lounges you might see a man in a grey suit. Nothing unusual there then. Well, not until he vanishes right in front of you.

The *Cutty Sark*, Greenwich, SE10

Clipper ship the *Cutty Sark* is a visitor attraction in Greenwich. It stands as a memorial to those in the Merchant Navy who lost their lives in the two world wars. Built in 1869, she visited major ports carrying cargo ranging from tea and gunpowder to whisky and was the fastest ship of her day. But this beautiful ship has two maritime ghosts. One is Captain Wallace, who jumped overboard; the other is sailor John Francis, who exchanged blows with a first mate after being insulted. The mate, a nasty piece of work, bludgeoned him to death. Both come back occasionally, just to check that their ship is in order.

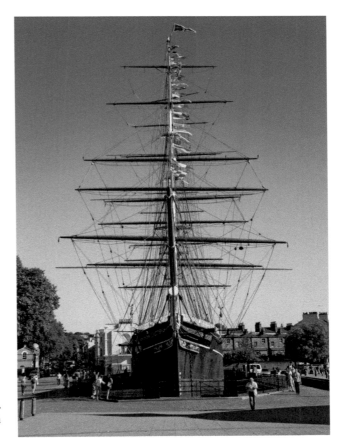

The *Cutty Sark*, a haunted visitor attraction in Greenwich. (© Visit London Images/Britain on View)

Acknowledgements

Love and thanks to Mike for suggestions, advice and cups of coffee. Thanks also to those who came forward with their own ghostly encounters for inclusion, particularly: Kerry Truman and Steven Thomson, who run the company Fright Nights London (www.frightnights-london.co.uk); Hazel Williams, James Williams, Dean Williams and Danielle Jackman of Spectrum Paranormal Investigations (www.spectrumparanormal. co.uk); and Jacqui Travaglia, owner of Lantern Ghost Tours (www.ghost-tours.com).

* * *

If you have any ghostly stories to tell, please contact me via my website, www.gillypickup.co.uk.

Are you one of them? (© Gilly Pickup)